The Picturesque Tour

In Northumberland and Durham, c.1720–1830

TYNE AND WEAR COUNTY COUNCIL MUSEUMS

Sponsored by Christie's and Northern Rock Building Society

Grant Aided by The Arts Council of Great Britain

A Catalogue to accompany the exhibition held in the Laing Art Gallery, Newcastle upon Tyne, 17 April – 31 May 1982

Designed by Tyne and Wear County Council
Published by Tyne and Wear County Council Museums
Sandyford House, Newcastle upon Tyne
and printed in England by
Inkerman Print Ltd. 1982.

ISBN 0 905974 06 9

Abbreviations In Text

NLS	National Library of Scotland
OW-CS	Old Water-Colour Society
R.A.	Royal Academy or Royal Academician
YCBA	Yale Center for British Art

Catalogue

All measurements are in millimetres, height before width;
abbreviations used are:

ref:	literary reference
repr:	reproduced
exh:	exhibited
prov:	provenance
illus:	illustrated here

Foreword and Acknowledgements

The term **Picturesque** commonly used to-day to describe scenes of pictorial interest had a more specific meaning in the eighteenth century, arising from the various surveys of antiquities and architectural subjects in landscape settings, illustrated by artists travelling widely throughout the countryside. By examining work produced by artists in the two historic (and former) northern-most counties of England and extending from Barnard Castle in the south to Lindisfarne in the north, and using much hitherto unpublished material, the exhibition traces an important aspect of the early history and development of the art of the English watercolourist. The exhibition and accompanying publication, the results of extensive and scholarly research by Gill Hedley, Museums Officer (Fine Art), at the Laing Art Gallery, will have a further interest as a documentary record of the appearance and character of this once remote region of England.

The collections of the Laing Art Gallery and Sunderland Art Gallery which figure prominently in the exhibition, including the recent acquisition of **Morpeth Bridge** by Thomas Girtin, have been most generously supplemented by important loans from public and private collections in order to make the exhibition as fully comprehensive as possible, and we are indebted to the institutions involved, listed separately in the publication. Anonymity of the private collectors unfortunately prevents us from thanking as individuals all those who have allowed pictures to be included from their own homes.

Exhibitions of this scale and importance involve high costs, and are becoming increasingly difficult for Local Authority Museums to present unaided. It is therefore gratifying to welcome the initiative of our two joint sponsors, Messrs. Christie, and the Northern Rock Building Society who between them have borne the largest part of this burden. The Arts Council of Great Britain has provided additional financial assistance and we thank them and the Paul Mellon Centre for Studies in British Art for their help, the latter towards the cost of illustrations in the publication. Northern Arts has set a practical and imaginative example in making available a travel bursary to enable Gill Hedley to visit art galleries and museums in Yale, New York, and Boston, in connection with her research. We would also wish to thank the Bowes Museum, for their contribution by supporting a special version of the exhibition to be shown at the Bowes Museum following the showing at the Laing, and thereby enabling it to be shared by a wider public.

The organiser Gill Hedley would like to thank the following individuals who have given her enthusiastic encouragement and considerable practical help in many different ways to enable **The Picturesque Tour in Northumberland and Durham** to be seen in the Laing Art Gallery:

Peter Bicknell
Anthony Brown
Elizabeth Conran
Bryan Crossling
Aidan Cuthbert
Joan Friedman
Andrew Hughes
Nerys Johnson
Michael Kauffmann
Alan Kemp
Mike Lavender
James Miller
Patrick Noone and staff of Prints & Drawings Department, Yale Center for British Art, Paul Mellon Collection
Roger Norris
Andrew Wilton
and anonymous lenders

Bill Craddock
Chairman
Tyne and Wear County Council Museums Committee

John Thompson
Director of Museums and Art Galleries
Tyne and Wear County Council Museums Service

Acknowledgements

We would like to thank the following institutions and individuals for lending works in their care:
Ashmolean Museum, Oxford 64, 71, 72, 73, 76, 105, 109.
Blackburn Art Gallery 130.
Bowes Musuem, Barnard Castle, Co. Durham. 36, 61, 85, 100, 102.
British Library 94, 95.
British Museum 22, 23, 47, 48, 75, 78, 79, 81, 88, 106, 123, 126, 128, 129.
Cecil Higgins Art Gallery, Bedford 101.
Dean and Chapter of Durham 34, 59, 60, 63, 114.
Earl of Scarbrough 62, 108.
Fitzwilliam Museum, Cambridge 49, 69, 77, 120, 121.
Leeds City Art Galleries 50, 87, 107, 127.
Library of the Society of Antiquities of Newcastle upon Tyne 2, 5.
National Gallery of Scotland 58.
Royal Academy of Arts 124.
Science Museum Library 18.
Sheffield City Art Galleries 132.
University of Liverpool 84.
Victoria and Albert Museum 20, 53, 82, 83, 104, 125, 131.
Whitworth Art Gallery, University of Manchester 86.
Williams Art Gallery, Birkenhead 118.
and all Private Collectors 3, 5, 6, 7, 8, 9, 14, 17, 37, 68, 80, 139, 144, 145, 146, 147, 148.

Permission to reproduce photographs has kindly been granted by the following:

Visitors of the Ashmolean Museum, Oxford, pp. 62, 73, 80.
Blackburn Art Gallery p. 91.
Trustees of the British Museum pp. 53, 57, 68, 71, 93.
Bowes Museum, Barnard Castle, Co. Durham. p. 78.
Trustees of the British Library pp. 75, 76.
Syndics of the Fitzwilliam Museum p. 67.
Leeds City Art Galleries p.89.
University of Liverpool p.70.
National Gallery of Scotland p. 61.
Sheffield City Art Galleries p. 90.
Victoria and Albert Museum pp. 69, 79, 88.
Walkers Art Gallery, Baltimore p. 87.
National Gallery of Art, Washington p. 86.
Yale Center for British Art, New Haven pp. 58, 66.
Private Collectors pp. 52, 94.

Contents

Permission to quote from unpublished manuscripts has kindly been granted by the following:
The Trustees of the National Library of Scotland
The Syndics of Cambridge University Library
Keeper of the Rare Books Collection, Yale Center for British Art
Newcastle upon Tyne Central Library

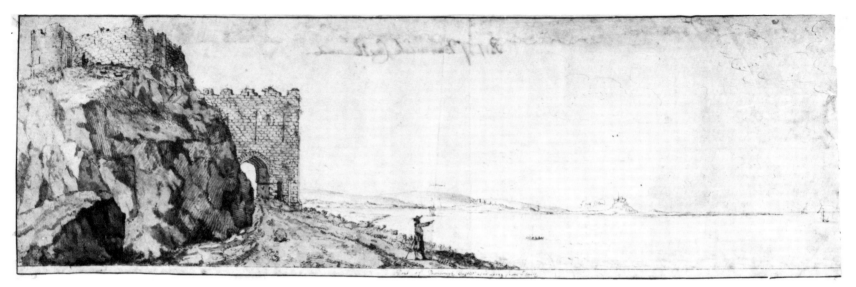

Francis Place, Bamburgh Castle, (122)

Introduction

The countryside of Northumberland and Durham has inspired and encouraged professional and amateur painters for nearly three hundred years. It is the intention of this catalogue and exhibition to examine views of the area both painted and written by a group of people between c. 1720–1830 who looked at landscape under the influence of the Picturesque.

Elsewhere, an attempt is made to define the Picturesque, discuss briefly the works of Burke, Gilpin, Price and Payne Knight, and outline the history of the fashion. It is sufficient here to say that the adjective "Picturesque" was a more complex way of describing the landscape than merely "pretty" or "scenic".

The Lake District, the Wye Valley or North Wales are the first places usually associated with the Picturesque but such areas attracted attention to their grandeur and wildness. Northumberland and Durham attracted the interest of antiquarians and topographers who were seeking out that aspect of the Picturesque which reveals itself in ruins, castles, abbeys and cathedrals. What better area? Professional historians and artists as well as amateurs became "Picturesque tourists" coping with difficult conditions to make long journeys to the North East, sketching, annotating and recording the landscape in diaries, journals and sketch books.

Some of this material is well known: the North East landscapes of Turner, Girtin and Cotman are frequently reproduced, and the drawings of Hearne, Dayes and Grimm, amongst others, were commissioned specifically to be reproduced through the medium of engraving and sold widely. However, sketches and private journals reveal a great deal about the way visitors to the area viewed it. The writers quoted here almost all responded to the landscape in pictorial terms. It is worth noting that the word "landscape" is used to describe both a painting and a specific piece of terrain. We still have no other word to differentiate between them.

The influence of Italian and Dutch landscape painting on the Picturesque will be discussed elsewhere. Many books have been written in recent years about the Picturesque using as illustration oil paintings by major figures such as Gainsborough, Wilson and Turner. The growing market for topographical and Picturesque guide books in the 18th century led to a vast number of beautiful water-colours being commissioned to record specific places, but in the Picturesque style: selective, modified and romanticised. Turner's **Prudhoe Castle** is a splendid example of distortion and embellishment for effect (illus. p. 93).

Water-colours are rarely singled out as the appropriate vehicle for explaining a period of British painting. Their own history and development is well

7

documented but water-colours have not been sufficiently accredited in recent surveys of the history of landscape painting. The close relationship between the Picturesque and the fashionable tour makes it clear that the new, portable medium of water-colour was dominant. J. H. Fuseli pointed out that sketches were intrinsically more Picturesque than finished oil paintings.

The fashion for the Picturesque started as an intellectual discussion between members of the landed gentry and eventually became a fad:

"Burke, and the 18th century generally, had all the zest and enthusiasm of children, newly discovering a park full of terrible woods, precipitious hills, and bottomless lakes".[1]

Inevitably, although there were dozens of professional artists employed by publishers to feed such a market, large numbers of amateur sketchers helped to develop the cult of the Picturesque. Visitors to Northumberland and Durham on the Picturesque tour fall into three separate categories: the professional artist; the amateur; and the Picturesque tourist who did not endeavour to sketch his or her "views" but wrote them down using a rich Picturesque vocabulary. The latter two categories consist almost exclusively of the highly educated: largely clergymen, an important sub-group of amateur artists, and lawyers. These two professions seem to have provided ample leisure for touring and there were plenty of contacts within Durham, Bishop Auckland and the Newcastle Assizes.

Few local painters or writers are included in this survey as they did not have the selective and curious spirit of tourists. Exceptions include the local amateurs who were taught by such important artists as Turner and Varley; and the 1st Duchess of Northumberland whose Picturesque tour diary of 1760 is a model of its kind, capturing the frissons felt when confronting the dramatic scenery of the North-East coast. She compiled a questionnaire for herself: "Is the place cheerful melancholy romantic wild or dreary?"[2]

Finally, the terminal dates of c. 1720–1830 should be explained. In the 1720s, Samuel and Nathaniel Buck began their major survey of great buildings, views which were Picturesque before their time; by the 1830s John Britton, the antiquarian, could write:

"The word Picturesque as applied to the antiquities of English cities will be recognised and understood by readers who are familiar with the works of Gilpin, Alison, Price and Knight. It has become not only popular in English literature, but as definite and descriptive as the terms grand, beautiful, sublime, romantic and other similar adjectives . . . (in) speaking, or writing, about scenery or buildings, is a term of essential and paramount importance."[3]

Later in the century, for the Victorians the word picturesque (no longer requiring its capital letter) could be applied to an enormous range of landscapes from the cottage scenes of Birket Foster to the oriental exotica of William Müller and J. F. Lewis. Many picturesque views were painted in Northumberland and Durham in the 19th century and the same views continue to be painted today: their Picturesque antecedents are worth examining in detail.

FOOTNOTES

1. Hussey, p. 56.
2. John Britton, *Picturesque Antiquities of English Cities*, 1830
3. Country Life, vol. 155, p. 250, quoted by Victoria Percy and Gervase Jackson – Stops.

THE PICTURESQUE

The Vicar's horse is beautiful, the curate's picturesque

Sydney Smith in **Lockhart's Life of Scott**, Ch. xxv

The Picturesque

The adjective "picturesque" is frequently used in conversation today when a view or landscape is described and the listener infers that the place in question is "as pretty as a picture". At its worst, the overtones are of the olde worlde appeal of thatched cottages and gardens, village greens and churches. It is an undramatic description and linked by association to chocolate box lids, calendars and tapestry designs. At best, to describe something as "picturesque" means that it would be a suitable subject for a painting, and by implication, a view that has often been painted.

In the second half of the 18th century, however, the term Picturesque, noun and adjective, was endlessly defined by writers on aesthetics and also a fashionable word and mode of thought for enthusiasts. It was used to describe landscape which was looked upon as a series of 'views': potential paintings. Professional painters, landscape gardeners, amateur artists and tourists all adapted the Picturesque as their 'practical aesthetic',[1] or measuring stick, for pictorial qualities. There was such a close and complementary relationship between words and paintings in the 18th century that the Picturesque was written about as often as it was painted.

A brief definition is necessary before the history of the fashion is explored. The Picturesque was a taste which became fashionable at the end of the 18th century for seeking out views in the landscape which, by virtue of their historical association, curious form, dramatic or romantic setting attracted the eye and satisfied the intellect. The passive form was found in the reading of travel guides and copying of their illustrations; the active form was to make a tour of the wilder parts of the countryside in search of Picturesque sights: "the first source of amusement to the Picturesque traveller is the pursuit of his object and searching after effects. This is the general intention of Picturesque travel."[2]

A new attitude to landscape painting was manifested in the interest shown by the aristocracy, in the middle years of the 18th century, free after years of war, in travel to the spectacular scenery of Southern Europe on their Grand Tour. Young connoisseurs were able to appreciate both the beauties of the landscape and the paintings of the Italian landscape by Claude, Gaspard Poussin, and Salvator Rosa. Such paintings, and their lesser equivalents, were brought home as souvenirs of the ideal landscape and recreations of that landscape on English estates were made possible through the skills of landscape gardeners such as "Capability" Brown and Humphrey Repton. At the same period, English poets were describing landscape in the same visual terms, most significantly, James Thompson's **The Seasons**, 1726–1730, which inspired numerous paintings (see cat. no. 125).

Written analyses of painting and aesthetics were an important part of the development of the British School of painting in the 18th century but, for the study of the Picturesque, the first important publication was Edmund Burke's **Inquiry into the Origin of our Ideas of the Sublime and the Beautiful**, published in 1756 and revised in 1765. This gave an emphasis to landscape painting which had previously been applied only to history painting.

Briefly, the Sublime was to be found in the paintings of Salvator Rosa where the wildness, power and scale of natural forces were emphasised: "precipices, mountains, torrents, wolves, rumblings, Salvator Rosa! . . ." as Horace Walpole exclaimed.[3]

Claude and Gaspard Poussin epitomised the Beautiful with its criteria of smoothness, regularity and gentleness. Their paintings were ideal landscapes, composed views, based on the scenery of the Roman Campagna, bathed in a golden light, and containing classical figures and architectural details.

Like the Picturesque, both terms were descriptions of scenery, expressed in terms of a painting.

English connoisseurs and patrons gradually began to buy landscapes by the Dutch painters of the 17th century, too, and their influence was most strongly felt in East Anglia where the trade was concentrated. The East Anglian landscape painter Thomas Gainsborough was the first major English artist to absorb the Dutch influence, producing a more naturalistic landscape with an emphasis on windmills, sandy river banks, gnarled trees, rustic bridges, peasants tending their flocks and tumbledown cottages.

Clearly, such landscapes were neither in the category of the Sublime nor the Beautiful. At the same time, the developing schools of topographers and tourists were discovering scenery in Britain neither Sublime nor Claudian but which, like the Dutch landscapes, was appealing to a growing market.

The most notable of the tourists was the Rev. William Gilpin (1724–1804), variously headmaster of Cheam and Vicar of Boldre in the New Forest. Gilpin was the son of an amateur artist and the brother of a professional one and began to collect prints at an early age. Later he became an enthusiastic traveller and took a sketching book with him on even the briefest stroll. He was one of the new generation of scholars, rather than aristocrats, who explored ideas of sensibility and aesthetics not on the classical Grand Tour but in the wilder and rougher scenery of their own country. As a result of travels which he made in the 1760s and 1770s, Gilpin began to write his own analyses of landscape, illustrated by his own entirely idealised monochrome views (see cat. no. 12). These were intended originally for private circulation in manuscript form but were later published with aquatint illustrations and were immensely popular.

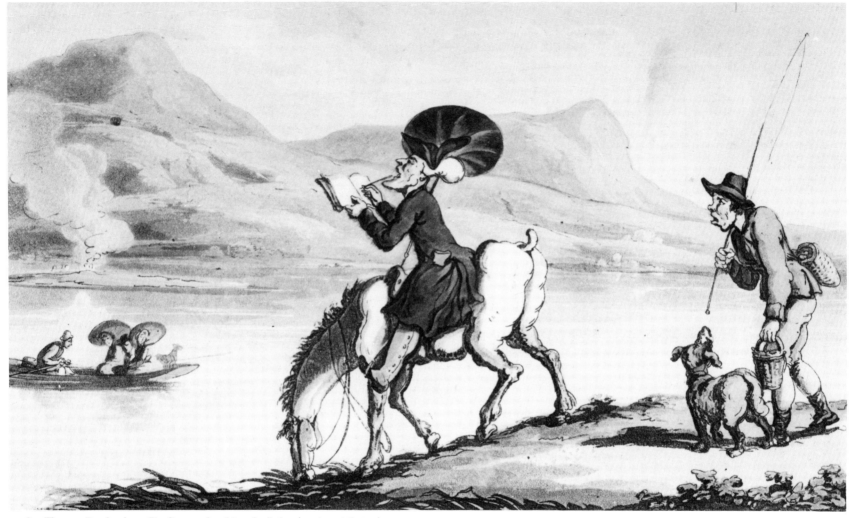

after Thomas Rowlandson, Dr. Syntax sketching the Lake, (not in exhibition)

Gilpin's tours were made in search of "Picturesque beauty", a portmanteau term invented by Gilpin to mean " that kind of beauty which would look well in a picture". Gilpin used "Picturesque" as a qualifying adjective but did attempt to isolate its qualities: "roughness forms the most essential point of difference between the **Beautiful** and the **Picturesque**: as it seems to be that particular quality, which makes objects chiefly pleasing in painting".[4] Not everybody agreed with this rather loose definition and after Sir Joshua Reynolds read the manuscript of Gilpin's essay on **Picturesque Beauty** in 1776, he pointed out that he believed everything beautiful was suitable to be included in a painting.[5]

Gilpin's attitude to landscape painting was that it must be selective. Picturesque elements had to be sorted out, improved upon and composed: "nature is always great in design; but unequal in composition. She is an admirable colourist; and can harmonise her tints with infinite variety, and inimitable beauty: but is so seldom so correct in composition, as to produce an harmonious whole."[6]

In 1838, William Pearson gave a revealing account of a layman's attitude to composing a landscape, in this case, at Brinkburn Priory. In view of the balance between Dutch and Italian influences in the formation of the Picturesque his last line is delightfully ironic:

"The view from ye west is ye finest: but ye ruins are not sketchable from that point from want of foreground. The fact is, Atkinson has not half an imagination: and from a foolish prejudice always prefers paintings things as they **are** instead of painting them as they **sh^d be**. For my part, if I were an Artist, I sh^d think it my duty if a thing was not right to **make it** so. And if a foreground wanted introducing here, I sh^d introduce it: and if a background wanted removing there I sh^d remove it. This has been ye privilege of painters from time immemorial . . . If I were a landscape painter I sh^d paint a view of Hopedale, a view of Tintern Abbey and a view of Conway Castle. And every valley that I painted I sh^d make like Hopedale: every abbey like Tintern Abbey and every castle like Conway Castle: and if I did not leave Gaspard Poussin, Claude Loraine and all ye kit of them far behind me in ye path of fame, "I am a dutchman"."[7]

For Gilpin, a range of Picturesque details was available in his imagination to improve a beautiful natural scene and these he passed on to his readers. These "amenities" included trees, shrubs, ruins and castles which added interest to the scene by virtue of their irregularity, roughness and historical association. These features characterise the Picturesque.

Gilpin came from Carlisle and, as a clergyman and teacher, his instincts were towards the Sublime and the awe-inspiring in nature so that the Lake District was his ideal. Although Gilpin was responding to a need for a new aesthetic between the Sublime and the Beautiful, his partiality to mountains, lakes and torrents makes him a contradictory guide.

He did, however, admit the need for man-made elements or "amenities" to add variety and sentiment to a scene and, in particular, that ultimately Picturesque detail, the ruin:

"It gains irregularity in its **general form**. We judge of beauty in castles, as we do in figures, in mountains, and other objects. The solid, square, heavy form, we dislike: and are pleased with the pyramidal one, which may be infinitely varied; and which ruin contributes to vary.

Secondly a pile gains from a state of ruin, an irregularity in its **parts**. The cornice, the window, the arch, and battlement, which in their original form are all regular, received from ruin a variety of little irregularities, which the eye examines with renewed delight.

Lastly, a pile in a state of ruin receives the richest decorations from the various colours, which it acquires from time. It receives the stains of weather; the incrustations of moss; and the varied tints of flowering weeds. The Gothic window is hung with festoons of ivy; the arch with pendant wreaths streaming from each broken coigne; and the summit of the wall is planted with little twisting bushes, which fill up the square corners; and contribute still more to break the lines."[8]

Gilpin did not approve of the current fashion for fabricating ruins but was still able to write of Tintern Abbey:

"a number of gable-ends hurt the eye with their regularity; and disgust by the vulgarity of their shape. A mallet judiciously used (but who durst use it?) might be of service in fracturing some of them; particularly those of the cross isles, which are not only disagreeable in themselves, but confound the perspective."[9]

There is no record of Gilpin visiting Northumberland but there are in existence "several sketches of the River Tees and its banks . . . (which) suggest that he was also in the North East of England in 1767".[10] Dr. Shute Barrington (1734–1826), Bishop of Durham from 1791, was a close friend so it seems likely that Gilpin would have taken the opportunity to visit such a Sublime spot as Durham Cathedral. It is interesting to note that in his **Northern Tour** Gilpin attributes the following famous Picturesque motto: "Here is Beauty indeed – beauty lying in the lap of horrour!", to Charles Avison (1709–1770) the Newcastle composer and organist of St. Nicholas's.

After Gilpin had introduced the concept of the Picturesque to the general public, two members of the landed gentry became the unlikely protagonists in an extended battle to define the Picturesque. Uvedale Price (1747–1828) of Foxley, Herefordshire and Richard Payne Knight (1750–1824) of Downton, Shropshire inherited their estates at an early age, completed their education as connoisseurs on the Grand Tour, and, accordingly, remodelled their houses and estates. Price began the contest by publishing **Essays on the Picturesque** in 1794; his close friend Knight published a poem, **The Landscape: A**

Didactic Poem in the same year and dedicated it to Price. In it, Payne Knight made a distinction between the Beautiful and the Picturesque to which Price took exception and Price, in reply, published **A Dialogue on the Distinct Characters of the Picturesque and Beautiful** in which a Mr. Howard and a Mr. Hamilton take Payne Knight and Price's positions in the argument and attempt to convince a Mr. Seymour, an innocent in Picturesque matters, of the worth of their arguments. Naturally, Mr. Seymour is convinced that Hamilton/Price is correct. Knight's final reply was an **Analytical Enquiry into the Principles of Taste**, 1805.

These are the publications in which the precepts of the Picturesque were set out as firm working principles.

Price characterised the Picturesque as the sum of those elements alien to what is beautiful: roughness, irregularity, abrupt variations. Salvator Rosa was cited as an example of a painter who achieved Picturesque effects; so were Rembrandt and Rubens. Knight, on the other hand, refused to distinguish between the Beautiful and the Picturesque, defining "Picturesque beauty" as merely beauty seen by those who have been trained in the principles of painting. It was this argument of Knight's that a future generation accepted and grand, sublime scenes or classically beautiful landscapes gave way to the genre scenes by Morland or Ibbetson of maidens by a cottage door or gypsies going to market. Such precedents allowed later painters to slide easily into the overt sentiment of Victorian cottage scenes, so often the criterion of what is called "picturesque" today.

In his criticism of Price, Payne Knight drew attention to the more extreme Picturesque conventions, which Price recommends. A preference for autumn over spring, for oak trees over fir trees or donkeys instead of Arabian horses was understandably Picturesque, but Payne Knight could not resist pointing out Price's reference to the Picturesque charms of a squinting girl. Moreover, Price recommends that cows are most Picturesque in the month of May when their rough coats are falling off. Such ludicrous details gave rise to the famous soubriquet: "The vicar's horse is beautiful, the curate's Picturesque".[11]

Gilpin, Price and Payne Knight were writing for relatively small audiences within the land-owning classes but the 18th century fashion for fads gave rise to a wider appreciation of the cult of the Picturesque:

"Tastes – they depend on fashion. There is always a fashionable taste: a taste for driving the mail – a taste for acting Hamlet – a taste for the marvellous – a taste for the simple – a taste for the sombre – a taste for the tender – a taste for banditti – a taste for ghosts – a taste for the devil – a taste for Picturesque tours – a taste for taste itself, or for essays on taste."[12]

Inevitably, such vogues were ridiculed but the very frequency of gibes at the Picturesque shows how prevelant a taste it was. Dr. Syntax was an acknowledged satire on the Rev. Gilpin and his tours:

"I'll make a TOUR – and then I'll
 WRITE IT.
You well know what my pen can do,
And I'll employ my pencil too:-
I'll ride and write, and sketch and
 print
And thus create a real mint;
I'll prose it here, I'll verse it there
And Picturesque it everywhere."

The fashion for the Picturesque as a social accomplishment is, predictably, best expressed by Jane Austen:

"He talked of foregrounds, distances and second distances; side screens and perspectives; lights and shades; and Catharine was so hopeful a scholar, that when they gained top of Beechen Cliff, she voluntary rejected the whole city of Bath as unworthy to make part of a landscape." (**Northanger Abbey**);

and in **Sense and Sensibility**:

"'Tis very true" said Marianne, "that admiration of landscape scenery has become a mere jargon. Everybody pretends to feel and tries to describe it with a taste of elegance of him who first defined what Picturesque beauty was".

"I like a fine prospect," said Edward "but not on Picturesque principles. I do not like crooked, twisted, blasted trees, I admire them much more if they are tall, straight and flourishing. I am not fond of nettles or thistles or heath blossoms."

Marianne looked with amazement at Edward".

The Picturesque cult was a transitional stage in painting and in poetry between the rational, intellectual and classical art of the 18th century and the emotive, imaginative and romantic art of the 19th century. Its origins can be traced to the 1720s when Thompson's first **Seasons** were published and the Buck brothers began their vast topographical survey. Flourishing in the period 1760–1800, the development of the great landscape painters, Girtin and Turner, lead the Picturesque into the romantic scheme of landscape where, by about 1830, personal vision dismissed such conventions.

The Picturesque

1. Hussey, p. 66.
2. Gilpin, **Three Essays,** 1792 (Hussey, p. 83).
3. quoted in Hussey, p. 95.
4. Gilpin, **Three Essays,** 1792, p. 6.
5. quoted in Barbier, p. 101.
6. Gilpin, **Observations on the River Wye,** 1782, p. 18:
7. Pearson, p. 85.
8. William Gilpin, **Observations on several parts of the counties of Cambridge, Norfolk, Suffolk and Essex, etc.,** 1809, p. 121-2.
9. William Gilpin, **Observations on the River Wye,** 1782, pp. 32-33.
10. Barbier, p. 33.
11. Sydney Smith in Lockhart's **Life of Scott,** Ch. xxv.
12. Thomas Love Peacock, **Melincourt,** 1817.

THE TOPOGRAPHERS

An enumeration of hill and dale, clumps of trees, shrubs, water, meadows, cottages and houses, what is commonly called views.

Johan Heinrich Fuseli, **Lectures on Painting**, 1820

The Topographers

"... the last branch of uninteresting subjects, that kind of landscape which is entirely occupied with the tame delineation of a given spot; an enumeration of hill and dale, clumps of trees, shrubs, water, meadows, cottages and houses, what is commonly called Views. These, if not assisted by nature, dictated by taste, or chosen for character, may delight the owners of the acres they enclose, the inhabitants of the spot, perhaps the antiquary or the traveller, but to every other eye they are little more than topography. The landscape of Titian, of Mola, of Salvator, of the Poussins, Claude, Rubens, Elzheimer, Rembrandt and Wilson, spurns all relation with this kind of map work. To them nature disclosed her bosom in the varied light of rising, meridian, setting suns; in twilight, night and dawn. Height, depth, solitude, strike, terrify, absorb, bewilder in their scenery. We tread on classic or romantic ground, or wander through the characteristic groups of rich congenial objects."[1]

So wrote J. H. Fuseli in 1820, professor of painting at the Royal Academy and a history and fantasy painter. The Royal Academy of Arts was founded in 1768 and its first president, Sir Joshua Reynolds, gave a series of addresses to the students of the Academy, known as Discourses, between 1769 and 1790, which have achieved the status of a manifesto for the early years of the school of British painting. A successful portrait painter himself, Reynolds considered the Italian Renaissance to be the highest point in the history of art. Accordingly, the subject matter popular at that period, history, mythology and biblical subjects, were considered to be the aim of all great art: portraiture, still-life and landscape were the lowest levels of this firmly established hierarchy. It is ironic to note that Reynolds singled out only one contemporary artist for praise: Thomas Gainsborough, especially for his picturesque "fancy pictures".

The Royal Academy had been founded by and for "Painters, Architects and Sculptors": painters quite specifically referred to artists who worked in oils. Those water-colours which were submitted to the Royal Academy's Annual Exhibition were referred to as "tinted" or "stained" drawings and were exhibited with prints and architectural designs in secondary rooms, "between windows and under windows, sometimes in the darkened room with the sculpture, where if they had merit, it could not be seen."[2]

The growing number of British water-colourists, almost all landscape painters and with the same energy that a generation before had led to the founding of the R.A., established their own exclusive exhibiting body in 1804: the Society of Painters in Water-Colour (later known as the "Old Water-Colour Society").

Water-colour is indigenous to Britain: illuminated manuscripts such as the Lindisfarne Gospels were decorated in that medium and a long tradition of miniature painting exists. However, the influence of Northern European artists who first added colour wash to their maps and later tinted their drawings of landscape, permeated the slowly developing national school of draughtsmen and landscapists and it was the English school of water-colourists who developed and expanded the medium, especially in the painting of landscape.

Continental example directed British painters until the end of the 18th century. In landscape painting 17th century French landscapists, Claude and the Poussins (more notably Gaspard than Nicolas) and the Dutch "little masters", Hobbema and Ruysdael, were the examples to emulate. The former produced ideal and beautiful landscapes, the latter were more naturalistic and often with those elements we have learned to call "Picturesque".

Visual records of the landscape were demanded by several groups of people: those who owned the land, historians, antiquarians and later, a new generation becoming conscious of the British countryside. Not only had the style and content of paintings been dominated by continental taste, but, up until the middle of the 18th century, so had the viewing of the landscape. First through poetry and literature, then through landscape gardening, an appreciation of the wild and ancient landscape of Great Britain came about. The cult of the Picturesque, with its response to the native landscape as opposed to the Italianate, developed the tendency.

As antiquarians and historians began to tour the country for material, so publishers began to sense a passive interest, felt by those who stayed at home, for illustrated guides to Picturesque areas. Through the writings of Thomas Gray and William Gilpin the Lake District became fashionable: "To **make the Tour** of the Lakes, to speak in fashionable terms, is the **ton** of the present hour".[3] Hussey points out, however, that other areas of the country were scarcely less fashionable if they had the attraction of castles, abbeys and cathedrals: "ruins and antiquities were part of the picturesque landscape from the first".

The Italian influence persisted in the 18th century when Joseph Smith, a British Consul known as 'the Merchant of Venice', encouraged Canaletto to come to England. Canaletto was already a well-established view painter in Venice and had many English clients. His first major commission in this country was from Sir Hugh Smithson, who later became the 1st Duke of Northumberland, to paint Northumberland House in London and Alnwick Castle, c. 1752.

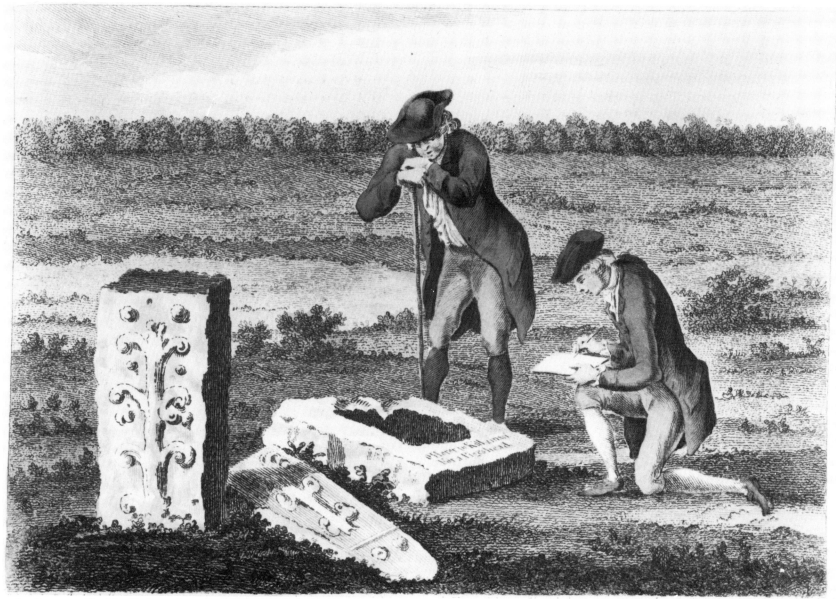

after Dramezer, The Monk's Stone, from Grose's Antiquities (not in exhibition)

It is possible that the latter was painted from an engraving or drawing rather than on the spot.

The medium of water-colour, sold in small, hard cakes from about 1780, later in moister form in paint boxes for sketching out of doors, was the obvious choice for artists on tour. Firms of colourmen, Reeves and Winsor and Newton amongst them, were established in the late 18th century and Thackeray

alludes to the latter very cleverly in his novel **The Newcomes** of 1853:[4]

"Before Clive went away, he had an apparatus of easels, sketching stools, umbrellas and painting boxes, the most elaborate that Messrs. Soap and Isaac could supply."

William Pearson describes his excursion into Northumberland:

"At length the day arrived "big with fate" on which we were to set out on our pedestrian excursion. There was a great deal of hurrying to & fro & a great deal of putting & off of knapsacks: but do what I would, I c^d. not make mine feel **light**, there being crammed into it, in addition to shirts, p^r. of trousers, shoes etc., Hooker's British Flora & a small portable flower press. Atkinson had ye advantage of me as far as ye two latter articles were concerned, but this advantage was counter balanced by an innumerable quantity of little matters which he carried, such as maps, sketching book, colour box, case of pencils, compass, water-bottle etc., & a cigar case so large that you might think that like Captain Bobadil, he was going to live solely "on ye fumes of that simple" – i.e. tobacco – for a week at least".[5]

In spite of Fuseli's derogatory definition, to be employed as a topographer was not a lowly calling. Water-colourists made their living either in that field or as drawing masters for the gentry, or a combination of the two, and only rarely could a water-colourist support himself by painting speculatively. It was commonplace for artists to set out during the summer months to make sketching tours either with a commission from a patron or publisher and sometimes with the idea of selling worked up water-colours from sketches that appealed to patrons.

It must be remembered that during this period physical discomfort was an inevitable part of any tour. The North East is almost three hundred miles from London and the long journey north was often made by sea. Geoffery Grigson suggests that this may be the reason for the "long views" or panoramas drawn by Hollar and Place.[6]

An advertisement of 1712, whilst informing the traveller that he or she could travel by stage-coach from London to Edinburgh for £4:10s added that the journey would take "thirteen days without any stoppage (if God permit)".[7] Moreover, the coach would not have been sprung. By 1750, coaches were drawn by two or four horses, carried six people inside and were faster and lighter, although still unsprung. By 1782, however, steel sprung coaches left Newcastle daily and the three day journey to London cost £2:10s.[8] John Pease[9] of Leeds toured the area in the winter of 1795–6

"in **our own** carriage; a light gig which we had bought for our more easy conveyance.... We mounted our Hobby about 12 o clock and arrived at Chillingham after a Ride of 20 miles across a barren Country so extremely Hilly we were oft obliged to descend from the carriage to ascend the steep Hills, which at the same time eased our Horse and warm'd ourselves."

Road conditions in the first half of the century were dreadful and responsibility for repair lay with the parish. This unsatisfactory arrangement was altered by the establishment of private turnpike companies who were granted parliamentary powers to erect gates and toll bars and were obliged to use the revenue to remake and maintain the highway. After the Turnpike Act of 1751 roads generally improved: between 1700 and 1750 400 Road Acts had been passed; between 1751 and 1790 the number had increased to 1600.[10] "All over England the appreciation of the scenery, the experiencing of romantic emotions and the perfection of the sublime in nature increased in direct ratio to the number of turnpike acts."[12] James Plumptre described the road between White Mare Pool and Gateshead in 1793 as "the worst turnpike road I ever saw, the ruts in some places were two feet deep".[11]

Although Dr. Syntax's adventures were by their nature exaggerated[13] (losing his way, being tied to a tree by highwaymen, being chased by a bull, falling in the lake he is sketching) it is easy to imagine that they were based in part on Rowlandson's own experiences. From notes scribbled in their sketchbooks we read of similar indignities to S. H. Grimm who was nearly arrested as a spy whilst sketching in Newcastle and John Glover who was disturbed by "drunken vulgar peoples" whilst sketching St. Nicholas' Church from a spot near a gin house.

Optical aids were the contribution of the scientific age to professional topography. Wedgwood sent the artists who were collecting views for his Catherine service[14] around the country with a camera obscura; Thomas Sandby, Joshua Reynolds and William Daniell were known to have used one. A forerunner of the photographic camera, a camera obscura consists of a small box with a convex lens, operated by bellows to focus. Above the lens is a mirror usually set at an angle of 45°. The view or object is reflected in the mirror through the lens on to a sheet of white paper on the base of the box where its outline can be traced. The camera lucida, patented in 1807, consists of a prism through which the artist sees an image of the view or object projected onto the surface

beneath. Cornelius Varley's patent Graphic Telescope of 1811 works on the same principle but with the advantage of magnification. Cotman used a Graphic Telescope in Normandy in 1817 and 1818 to aid the drawing of architecture.

It is, however, a Claude glass that was most frequently used by the Picturesque tourists hoping to turn the landscape into an instant Claudian view. The Claude glass consists of a portable convex mirror of blackened glass, or silvered for a dark day. Coloured filters were also available. Thomas West in his **Guide to the Lakes** explains the use of the glass: "the person using it ought always to turn his back to the object that he views. It should be suspended by the upper part of the case holding it a little to the right or left (as the position of the parts to be viewed requires) and the face screened from the sun'.[15] The resulting reduced image can then be copied. William Pearson[16] can always be relied upon to give the negative view of a fashion, and in this case, an indication of its cost

"Bought also a Camera Lucida on ye recommendation given of it by Basil Hall in one of his books. I had been purposing to buy one for two years; I have now bought one & had it in possession for two & have taken it out of ye case **once** since I returned & that merely to shew a friend. I begin to think my sovereign would have done me more good if left in my pocket".

The early topographers conceived their drawings with a reproduction by the engraver or etcher in mind. Accordingly, the design was primarily linear, based on on-the-spot pencil sketches, worked up to a line drawing and then given tone and colour by means of a water-colour wash. Little attempt was made at first to render colour accurately as the taste in water-colour was for cool grey-blue tones and it is not until the early years of the 19th century that warm earth tones are regularly employed. By that time, water-colour had achieved a higher status and an independence from engraving. "The method of washing colour over monochrome under-painting was shared in common by most of the topographers up till about 1800, though each painter showed individual characteristics of style. Being dependent for its shadow effects on black and white rather than colour, it was an ideal kind of drawing for the engraver to reproduce. The engraver in aquatint, working as it were in washes of tone and not having to break up and interpret shadow by means of lines, like the line engraver and the wood engraver found it easy to make an almost exact facsimile."[17] Engraving was the most popular method of printed reproduction, but increasingly, etching in aquatint became popular for the production of water-colour as it is a tonal rather than linear process. First introduced into England by the topographer Paul Sandby in 1775, aquatinting is a method of etching, that is, the biting of a copper plate by means of acid. Through partial protection of the plate by means of a scattering of resin particles, between which the acid can bite, a pitted surface results which enables the plate to hold ink and print in a liquid finish which closely resembles a water-colour wash. The outline is usually achieved by pure line etching. Later artists, especially Turner, rejected the aquatint in favour of finer engraving usually upon steel. Although these later prints are referred to as engravings they are more accurately described as etchings because the majority of the lines are bitten, with details only highlighted by means of the graver. Turner trained several engravers to reach a very high standard of sensitivity and fidelity to his delicate tones through constant supervision and correcting of the proofs pulled from the first plates. Turner's achievement lead to the establishment of steel engraving as the successor to aquatint in the reproduction of landscape views. The last flowering of topographical views was in the popular annuals, such as the **Landscape Annual** which employed J. D. Harding, David Roberts and James Holland from 1832–1839 and **Heath's Picturesque Annuals** which reproduced the work of Clarkson Stanfield, A. G. Vickers, George Cattermole and William Callow amongst others. By the time steel engraving was firmly established the influence of Picturesque theory on water-colour painting was diminishing.

Topography has a very pure line of descent and has been almost consistently produced in response to a market. The German artist Wenceslaus Hollar, court artist to the Earl of Arundel, was the first creative topographer to record the landscape of Britain. His associate Francis Place continued a tradition which was to enjoy longevity in this country. Both artists inherited their method of painting, in neutral washes over a stronger outline, from Dutch painters of the 17th century who in turn derived the technique from the tinting of maps and engravings "with gummed colours, but tempered very thinne and bodilesse".[18]

Martin Hardie[19] provides us with further useful information: "if the topographer was painting a red brick bridge and a tree, he drew his subject in outline; indicated the shadows on the tree and under the arch of the bridge in a grey wash; finally painting a pale green all over the tree, including the shadows and a red over the entire bridge, including the shadow under the arch. He was not considering to any great extent "local colour". Later on, artists painted their shadows with colour, not with a neutral tint. They saw and suggested varying greens on the tree, and noted that the bridge was yellow and red and brown in parts, while the shadow under it was warm with reflected colours. In painting local colour, the later men put a dark green over a light one, a

deeper red over a pale red, or laid a wash of warm yellow over tree and bridge, running darker colours into it while it was still wet. The topographers worked in the reverse way, always putting light tint over dark."

Daniel King (c. 1610–1640) worked in a similar manner to Hollar and produced **An Orthographical Designe of Severall Views upon Ye Road in England and Wales**, intended to accompany Camden's **Britannia**, so "that where he mentions such places the Curious may see them". One of these miniature views is of Lambton Colliery in Co. Durham: a very early view of an industrial site.

The next major topographical publication was **Britannia Illustrata** (first published in 1708) with etchings and engravings by Johannes Kip after drawings by a fellow Dutchman Leonard Knyff, and others. Before publication of the third of four volumes, a note appeared in the reprint of the first two: "Any Gentlemen paying Five Guineas towards the Graving may have their Seat inserted". Country houses and their formal gardens were the subject of this publication rather than landscape views.

Specific buildings were the subject of the huge project undertaken by Samuel and Nathaniel Buck, between about 1720 and 1750, to illustrate "the venerable remains of above four hundred Castles, Monasteries, Palaces, etc. in England and Wales". The plates were published as a collection in three volumes by Robert Sayer in 1774. Roget[20] described the naivety of the early prints by the Bucks in which "there is little or no imitation of actual texture. Ruined walls had none of the look of crumbling stone. Edged with fringes of vegetation, neatly trimmed little whiskers, they are themselves perfectly smooth, as if cut in wood or carved, showing marvellous coherence in broken arches and masonry". Their technique improved, and greater attention to accuracy and detail appears in later prints.

Many of the best topographical publications of the late 18th century appeared in instalments, such as Francis Grose's **Antiquities** which appeared between 1773 and 1787 and **The Copper Plate Magazine** published in five volumes between 1792 and 1802 and made up of forty two numbered parts which sold for one shilling each. John Walker was responsible for almost all the engravings which were made after artists including Dayes, Girtin, Turner and Varley. In 1799, Walker retouched the plates and reissued them in one volume as **The Itinerant: a Select Collection of Interesting and Picturesque Views in Great Britain and Ireland: Engraved from Original Paintings and Drawings by Eminent Artists.**

The most ambitious of all topographical publications of the period was produced by John Britton and Edward Wedlake Brayley. According to biographical notes written in 1828 and recorded by Russell,[21] "Britton read Burke's 'essay of the Sublime and the Beautiful' and the various writings on the Picturesque of William Gilpin, Uvedale Price and Richard Payne Knight, and enjoyed R. Warner's two **Walkes Through Wales**, 1797 and 1799. Determined to see for himself, he set out on his own walking tour, with maps, compass, two or three books, camera obscura, umbrella and underwear, leaving London on 20th June and visiting Windsor, Oxford, Stratford, Warwick, Birmingham, Church Stretton, Shrewsbury, Welshpool, Ludlow, Ross, Chepstow, Bristol, and Bath. The tour took just over three months and Britton meticulously recorded the cost, £11-16-9d – viewing Blenheim Palace cost him 2/6d".

Britton's **Beauties of Wiltshire** appeared in 1801 and the publishers Vernor and Hood persuaded Britton and his friend Brayley to undertake a vast topographical study of England and Wales, to appear monthly and later in collected form, which turned out to be twenty-five volumes. They agreed and the publication had the lengthy title **The Beauties of England and Wales, or Delineations, Topographical, Historical, and Descriptive of all the Counties, collected from authentic sources and actual survey, by E. W. Brayley and J. Britton**; "accompanied with engraved plates of celebrated remains of antiquity, or of architectural elegance, noblemen's and gentlemen's seats, or the grand productions of nature". The authors were perfectionists and made extensive tours to see the views for themselves, covering over three and a half thousand miles by the end of the fifth volume which appeared in 1804. By this date, the circulation of each number was between three and four thousand, but in spite of this obvious popularity, the publishers objected to the authors' emphasis on antiquities and would have preferred greater attention to the houses and estates of potential clients. **The Beauties** contained over seven hundred engravings of which at least three thousand prints were issued, and amongst those artists who supplied drawings were Dayes, Hearne, Sandby, Munn, Varley and Turner. Britton's other major publications include **Picturesque Views of English Cities**, after drawings by George Fennel Robson, 1826–1827, and the **Picturesque Antiquities of English Cities**, 1828–1830. The extent of the contemporary interest in topography can be measured from the fact that between 1803–1810 Britton was asked to review nearly one hundred and fifty antiquarian and topographical books for the **Annual Review**.

The Topographers

1. J.H.Fuseli, **Lectures on Painting,** 1820.
2. Robert Hills, quoted by Roget, 1, p. 130.
3. **Monthly Magazine,** 1778, quoted in Carrit, p. 360.
4. Quoted by Hardie, p. 21.
5. Pearson, p. 30.
6. Geoffery Grigson, **Britain Observed,** 1975, p. 22.
7. P.M. Horsley, **Eighteenth Century Newcastle,** Newcastle upon Tyne, 1971, pp. 220
8. Ibid., p. 220.
9. John Pease, **Journey of an English traveller in Scotland, winter 1795-6, MS** 6319 (21), National Library of Scotland.
10. G.M. Trevelyan, **An Illustrated English Social History,** 1944, vol. 3, pp. 86-9.
11. Plumptre, 166/30, University of Cambridge Library.
12. Hussey, pp. 100-1.
13. Combe and Rowlandson, **The tour of Doctor Syntax, in search of the Picturesque A Poem,** 1812 (see p. 24).
14. See appendix.
15. Thomas West, **A guide to the Lakes,** 1778.
16. Pearson, p. 163.
 Basil Hall (1788-1844) was a Captain in the navy, best known for his **Fragments of Voyages and Travels,** 3 vols, 1831-33.
17. Hardie, p. 162.
18. Ibid. p. 161.
19. Ibid. pp. 161-2.
20. Roget, 1, p. 14.
21. Russell, p. 50.

THE ANTIQUARIANS

"Antiquarian, antiquary: a man studious of antiquity: a collector of ancient things."

Samuel Johnson, **Dictionary of the English Language**, 1755.

The Antiquarians

From an early date, the antiquarian had been an obvious target for caricature; amateurs particularly were associated with eccentricity and pedantry as well as scholarship. Robert Adam, the architect, described himself as "antique man, or what they would call in Scotland an Antick".[1]

The cultural education of the young British nobleman in the 18th century was considered incomplete without a lengthy Grand Tour to Italy, and possibly Greece, to visit the sites of classical civilisation and their antiquities. Greek and Roman artefacts and ruins were considered to be the peak of artistic and cultural achievement just as the Italian landscape was considered the Ideal. The subsequent developing interest in the native landscape was paralleled by an interest in British history and British antiquities and so a passion for travel, seeking scenery and ancient monuments within the British Isles, developed. "The English countryside swarmed with inquisitive parsons whose love of antiquities was often their most sincere profession ... by 1762 the English public was more curious about antiquities than ever before."[2] The mania affected the nobility as well as parsons and serious students and a vast number of publications brought the subject to an increasing middle class audience.

Anon, 1789: "The more I consider the numerous Advantages arising from Travel, the greater Pleasure I receive from reflecting the Love of this species of Education rages with encreasing violence in the Breast of my Fellow-Countrymen.

...it is an easy Thing to sit by your Fire-side and read the Adventures of others, and glut your Imagination with various Descriptions of ancient Towns and Castles, Romantic Scenery, Picturesque Views and Churches once dedicated to the Almighty falling to Decay under the rough Hands of devouring Time".[3]

The 18th century in Europe was a period of intellectual discoveries: the first encyclopaedias and dictionaries were written and, on a popular level, curiosity and "historicising" were the fashion. Thomas Chatterton wrote medieval lyrics and passed them off as discoveries; ruins were newly-built on country estates and collecting became a national pastime. At Hadrian's Wall, Sir John Clerk of Penicuick writes that it was possible to take away carved stones and sculpture for a few pence.[4] On a scholarly level, the Society of Antiquaries was founded in London in 1717, in Edinburgh in 1780 and The Literary and Philosophical Society in Newcastle upon Tyne in 1793. The first antiquarian publications with their weighty Latin titles and sheer physical weight needed illustrations by professional artists both to win public appeal and to provide a useful record. Pages of engravings of Roman coins contributed nothing to the history of art but the Picturesque and topographical views demanded by the antiquarian or suggested by his artist are the subject of this study.

Wealthy amateurs were able to be generous patrons and James Moore, Francis Grose and Dr. Richard Kaye enabled dozens of superb water-colours to be painted. Parochial specialisation was clearly too restrictive to the enthusiasts of a comparatively young discipline: travel was the thing. "If ruminating upon antiquities at home be commendable, travelling at home for that purpose can want no defence."[5] Note that "at home" is specified: the enthusiasm for anticking grew at the same pace as the love for the British countryside in painting and literature. The creeping influence of the industrial revolution, its effect on the appearance of the ancient landscape and its aggressive modernity gave a renewed energy to appreciative and escapist studies of the old and the beautiful.

If the 18th century was a period of curiosity and discovery, Britain in the latter half was a place of extraordinary enthusiasm and fads. Also the peak of satire in the novel and in illustration, we have many contemporary satirical views of antiquarians and their less scholarly counterparts, the writers of the guides to the Picturesque and the antique. The most famous is Doctor Syntax, a combination of "Don Quixote with Parson Adams";[6] a caricature of William Gilpin, the most influential of writers on the Picturesque, but also a satire on a general taste.

The publication had a curious beginning; it appears to have been suggested by the artist Thomas Rowlandson to the publisher Ackermann who had been very successful with his own series of Picturesque Tour publications. Rowlandson's idea was to produce a series of aquatints showing a country curate travelling about England, the first series inspired by the cult of travel books. Ackermann agreed to the project and commissioned William Combe to "illustrate" Rowlandson's work with ten thousand lines of verse. Combe was sent one drawing at a time to his debtor's cell in the King's Bench prison and by this curious and impeded process a tremendously popular book was produced. Entitled **The Tour of Doctor Syntax in Search of the Picturesque**, it was published in serial form in the **Poetic Magazine** from 1809 and first appeared as a separate volume in 1812. It was immediately and generally popular. Doctor Syntax was both a curate and a school master, lean and comical with a long nose and a rusty black suit and the mixture of the studious and the ridiculous in his many misadventures guaranteed popularity. Translations proliferated, ceramic figures were made and two pubs in the North East still bear his name. Combe later wrote of a Doctor Prosody (a relation of the Syntax family) and his tour to Scotland "with intent to seek/Objects both curious and antique".[7]

It is generally considered that antiquarian study started with John Leland, born in 1506. The first major publications to deal with the antiquities of the country as a whole were William Camden's **Britannia**, 1586 and William Dugdale's **Monasticon Anglicanum**, 1655–73.

Richard Gough (1735–1809) began his antiquarian studies at an early age publishing a history of the Bible when he was eleven. He left Cambridge without a degree and travelled all over Britain making notes for a new edition of Camden's **Britannia**. He was for many years Director of the Society of Antiquaries as well as a Fellow of the Royal Society. He had an independent fortune which enabled him to amass a large library and collections, a great part of which, including a large number of drawings by Grimm, went to the Bodleian Library, Oxford.

William Stukeley (1687–1765) was a doctor of medicine who believed that tours cured his gout. He and a colleague, Richard Gale, made extensive antiquarian tours throughout England and in 1725 they walked the length of Hadrian's Wall and "drew out (for he was a respectable draughtsman) and described innumerable old cities, roads and altars".[8] This tour was published as **Iter Boreale**, within the **Itinarium Curiosum**, in 1725. In 1754 he met the Princess of Wales whilst at dinner at Carlton House: "She wondered I never travelled abroad. I answered that I loved my own country and that there was curiosity and antiquity enough at home to entertain any genius, ... that the Northumbrian Wall was the greatest work the Romans ever did anywhere; but I had travelled the whole length of it, and taken drawings of innumerable inscriptions, altars, basso relievos, milliary pillars and the like, found thereabouts and now lie neglected."[9] The Princess was clearly interested in Stukeley's work in Northumberland and he wrote to her later that year, "when Mr. Gale and I were there, we tired ourselves day by day in copying and drawing inscriptions".[10] He enlisted the Princess's help in preventing further desecration of the wall carried out by surveyors doing improvements.

Robert Surtees (1779–1834) was born in Durham and educated at Houghton-le-Spring. He lived in Mainsforth, Co. Durham and had made plans to write a history of the county whilst still an undergraduate. He travelled the area with a groom who later complained that it was "weary work" as they could never go past an old building without stopping. The **History of County Durham** appeared in four volumes between 1816 and 1840. Surtees became a friend of Walter Scott and played a very "anticking" joke upon the author. Surtees sent Scott a supposedly newly-discovered medieval ballad, **The Death of Featherstone Haugh**, complete with a glossary of archaic terms and historical footnotes; it was a complete fabrication. Scott included part of it, however, in the first canto of his great Northumbrian ballan **Marmion** and the whole of it in a new edition of the **Minstrelsy**. Scott later said Surtees "was chiefly the cause" of writing **Marmion** at all. Scott visited Mainsforth in 1809 and an untenable tradition has it that he wrote part of **The Antiquary** there. The true authorship of **The Death of Featherstone Haugh** was not revealed until after Surtees' death. Scott wrote to the poet Robert Southey, asking him to let Scott know "if you make any stay in Durham as I wish you to know my friend Surtees of Mainsforth. He is an excellent antiquary, some of the rust of which study has clung to his manners: but he is good-hearted".[11]

In Walter Scott's **The Antiquary**, published in 1816, he wrote a description of an antiquarian's study, based on his own eye-witness account of the study of Sir John Clerk of Penicuik:[12]

"A large old fashioned oaken table was covered with a profusion of papers, parchments, books and nondescript trinkets and gew-gaws which seemed to have little to recommend them, besides rust and the antiquity which it indicates. In the midst of this wreck of ancient books and utensils, with a gravity equal to Marius among the ruins of Carthage, sat a large black cat, which, to a superstitious eye, might have presented the **genius loci**, the tutelar demon of the apartment. The floor, as well as the table and chairs, was overflowed by the same **mare magnum** of miscellaneous trumpery, where it would have been as impossible to find any individual article wanted, as to put it to use when discovered."

Such imagery clearly followed the traditional view of alchemists in their cells and had the same curiosity value.

Maps and guide books were vital aids to amateur and professional antiquarians, artists and Picturesque tourists in general. Capt. Armstrong produced the first one inch to the mile maps of Northumberland and Durham in the 1760s. His four sheet map of Durham was published, with a map of the city in one corner, in 1768, and a nine sheet map of Northumberland with a Companion, in 1769, with a convenient one sheet version appearing later.

A brief summary of the available guides may be useful:

NORTHUMBERLAND

1767 John Wallis, The Natural History and Antiquities of Northumberland & of so much of the county of Durham as lies between the Rivers Tyne and Tweed; commonly called the North Bishoprick

after S.H. Grimm, History Preserving the Monuments of Antiquity (99)

1778	William Hutchinson, A View of Northumberland with an excursion to the Abbey of Mailross in Scotland, Anno 1776
1785–1794	William Hutchinson, History and Antiquities of Northumberland
1820–1858	John Hodgson, History of Northumberland

NEWCASTLE UPON TYNE

1736	H. Bourne, History of Newcastle
1789	John Brand, History and Antiquities of Newcastle

DURHAM

1787	William Hutchinson, History and Antiquities of the County Palatine of Durham
1816–1840	Robert Surtees, History of County Durham

The Antiquarians

1. Brown, p. 7.
2. Lipking, p. 141.
3. MS 1080, NLS.
4. Brown, p. 20.
5. Ibid. p. 28, quoting William Stukeley.
6. **The Cambridge History of English Literature,** vol. XIV, Ch. VI, p. 221.
7. Brown, p. 29.
8. **Dictionary of National Biography.**
9. **Family memoirs of the Rev. William Stukeley etc.,** Proceedings of the Surtees Society, vol. 80.
10. Ibid.
11. Pope -- Hennessy, p. 159.
12. Brown, p. 17.

VIEWS OF NORTHUMBERLAND AND DURHAM

If I had good weather on this expedition I should have been well enough diverted on it, there being more valuable and agreeable things and places to be seen than in the tame South of England.

Sir John Vanburgh, 1721, on Northumberland
(BM Add. MSS 33064, ff 213)

Northumberland and Durham

It is often said that in 18th century Britain ideas were first expressed verbally before they were realised visually.

"The patrons and artists of British landscapes were, not always deeply, but certainly much of the time, concerned with poetry and prose; there is a deal of truth in the notion that art was verbally framed before becoming visually real ... those who viewed and/or bought pictures naturally gave them a literary setting."[1]

It is therefore important to turn to early diarists and letter writers for the first "points of view" and perceptions of the landscape of Northumberland and Durham. Published guides were clearly a primary source for subsequent tourists and the private diaries of various travellers reflect, often amusingly and revealingly, contemporary attitudes.

It is possible to gather from the words of travellers which routes were favoured and which monuments, view and sites were singled out. The market for topographical books both fed and responded to such writers.

Celia Fiennes (1662–1741), wrote a vivid and enthusiastic description[2] of the whole of England which shows itself to be without any self-conscious reference to Picturesque ideals. She alternates statistics with details of curiosities like the ghoulish anatomical specimens of the Barber Surgeons' Hall in Newcastle upon Tyne. In 1725, the journalist and novelist Daniel Defoe also wrote a description[3] of the whole of England and, in the section devoted to Northumberland and Durham, writes:

"here is abundant business for an antiquary; every place shows you ruined castles, Roman altars, inscriptions, monuments of battles, of heroes killed and armies routed and the like.... I cannot but say, that since I entered upon the view of these northern counties, I have many times repented that I so early resolved to decline the delightful view of antiquity, here being so surprising a variety, and every day more and more discovered. I resolve once more to travel through all these northern counties upon this very errand and to please, nay, satiate myself with a strict search into everything that is curious in nature and antiquity."

Defoe shows an early awareness of the difference between reportage and the observation of the curious and the Picturesque. Arthur Young, in 1770, published his **Northern Tour** and created a balance between agricultural statistics and Picturesque detail.

Until the number of topographical books expanded, the rest of England had a limited knowledge of the North East landscape and its agriculture was not the characteristic that came first to mind. Horace Walpole acknowledged the fame of the North East: "the best sun we have is made of Newcastle coal" (Letters, 15th June 1768) and eight years before, R. J. Sullivan[4] had declared that "to have been at Newcastle, and men of curiosity, too, without seeing a coal pit, would have been a sin of the most unpardonable nature." Most informative is the description of the area given in **Iter Borealis** by John Tracey Atkyns[5] who, in 1732, noted that the "coalways are worth the observation of any traveller". A response to an industrial landscape was almost always couched in terms of the Sublime, although the effect is of man and his works on the face of nature and not vice versa. Most travellers to the North East mention coal pits and glasshouses but often found the industrial view beyond their visual terms of reference. Others, J. M. W. Turner most notably, saw the dark and glowing landscape as poetic, Sublime and romantic and nowhere expressed so clearly as in **Keelmen Hauling Coal by Moonlight** (illus. p. 86).

The great religious buildings of Northumberland and Durham, ruined or complete, usually caused a response couched in terms of their antiquity, splendid site or historical association; the dramatic coastline was the only aggressive aspect of the landscape and therefore few reactions are made in terms of the Sublime. The exceptions are curious. An anonymous journal writer[6] of 1789 records a reaction to a contemporary monument:

"on my return to Newcastle I passed over Tanfield Bridge (commonly called Causey Bridge) a structure the most awful and magnificent my Eyes ever beheld, it consists of one single Arch, 178 feet High and 102 feet wide, thrown over a deep Glen whose steep sides are covered with a rich luxuriancy of wood watered at the bottom by a rapid rivulet."

With greater affectation, Elizabeth Montagu[7] writes in a letter about Gibside:

"Gibside is too great for me. I love woods but I do not desire such forests that you would rather expect to be entertained in the evening with the howling

and yelling of tygers than with Philomel's love-laboured song."

The relationship between the Sublime and the Picturesque in the Northumbrian landscape is most clearly expressed by Tracey Atkyns[8] when he describes the balance between an ancient monument and its dramatic site at Tynemouth:

"I landed among the rocks in a place called Priors' Haven, the most monstrous ones I ever saw, a horrid yet a pleasing look at the same time, over'em is a lighthouse and a house belonging to the Government."

Criticism was often in social terms as in Tobias Smollett's **The Expedition of Humphrey Clinker**, 1771:

"the City of Durham appears like a confused heap of stones and brick . . . as for Newcastle, it lies mostly in a bottom, on the banks of the Tyne, and makes an appearance still more disagreeable than that of Durham."

Nor were all early tourists impressed by the ancient monuments that are part of today's tourist trail:

"The place they call the Roman Wall w[ch] was built by the Romans to part England and Scotland and it runs from Tinmouth Priory almost to Carlisle but now it is quite worn out and I could see nothing of it tho' the people here ab[t] pointed to me the worn ground on w[ch] it stood".[9]

Artists, antiquarians, and writers seemed to have followed a broadly similar path on their various tours of the North East. The first stop was usually Durham: a great many Picturesque tourists were in holy orders or were lawyers and had friends or colleagues to visit in Durham. The city was famous for the magnificent cathedral and ancient castle in their spectacular setting but an early tourist shows the attitude of the pre-Picturesque generation:

"the whole situation somewhat romantic, but to me not unpleasant . . . but others of better judgement condemn this site, to whose opinion I always submit my own, to my great advantage and instruction". (Diary of the Earl of Oxford, c. 1723).[10]

Thomas Gray, thoroughly conversant with Picturesque principles, wrote in 1753:

"One of the most beautiful vales here in England to walk in, with prospects that change with every ten steps, and open something new whenever I turn me, or rude and romantic; in short, the sweetest spot to break your neck in or drown yourself in that ever was beheld." (Thomas Gray, from Durham, 1753).[11]

In 1767, he wrote, "tomorrow I go vissing to Gibside to see the new married Countess."[12] Private parks were often opened to the public:

"From Newcastle I made a pleasing Excursion to Gibside, the delightful seat of the Countess of Strathmore, situated on the river Darwen; no Man of the least Feeling can see this charming Place without being sensibly affected with the rapid desolation everywhere taking Place around it, yet it has even now, after 9 years Neglect, sufficient majesty to engage the Attention of every Traveller fond of romantic Scenery." (Anon. 1789)[13]

Castle Eden Dene, the largest of the valleys which lead down to the North East coast between Sunderland and Hartlepool, was a popular beauty spot for Victorians from about 1850 when the Rev. John Burden allowed the general public to visit on payment of a small fee. In 1757 Rowland Burden of Newcastle bought the estate, which included ruins of a castle and chapel, rebuilt the chapel and built a new house in 1764. By about 1790 his son had improved the Dene, too, "opening out the picturesque dene road from just above the Castle to the sea. Thus the most magnificent of magnesium limestone glens which fringe the eastern coast of the County of Durham was rendered accessible through its whole length, revealing its wild beauties at every turn."[14] By the 1820s the Dene had become an attraction for Picturesque tourists.

John Sell Cotman visited the Dene in 1805 on the recommendation of his friend and patron Teresa Cholmeley who wrote to her husband that year:

"(Castle Eden Dene) far surpassed my most sanguine expectations! . . . The valley is full of the most interesting changes and inequalities of ground. Sometimes you have a steep tho' short hill to ascend, and then as precipitate a descent. Often by rustic bridges or fords you pass a stream or rather the bed of a stream, but whose rocky or stoney channel has great beauties tho' generally devoid of water. Immense rocks rise of either side, sometimes abrupt, sometimes receding and of various colours and kinds. Fine ash, oak and elm flourish tho' almost apparently growing out of the rock itself, which

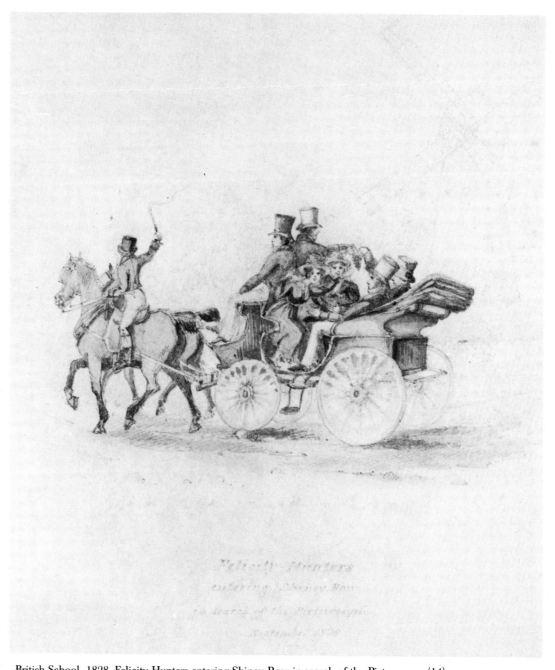

British School, 1828, Felicity Hunters entering Shiney Row in search of the Picturesque, (14)

rocks are sometimes cloath(e)d w(i)th festoons of ivy, sometimes with thick dark masses of yew (which grow there in great abundance) and sometimes presenting a bold naked surface, seen thro' the light airy foliage of the ash. Frequent recesses and even apparent caverns also occur, some near, some higher up in the receding rocks. The road always seems conducted in the purest simple taste, often overhung by embowering trees that cross it in wildest fantastic shapes, and reminded of the low garden walk at Rokeby by the side of the Greta. You have one grand view of the **castellated** house rising proudly over the tops of the woods & which put me much in mind of Mrs Radcliffe's Castle of Udolpho, and another view for which you turn a little out of the road to a thatch(e)d seat, magnificent to a degree! A steep & broad valley of wood, & near the centre one single rock of the most exquisite grey tint I ever beheld, simply projecting! When I saw it the sky had thicken(e)d & misty rain was beginning to fall, but the scene wanted no glaring lights. All was in perfect harmony. I do not think it c(oul)d be seen to more sublime advantage! Sunderland bridge after all this appear(e)d but as a wonderful production of that ingenious & industrious Pismire, **Man**! It gave me no higher pleasure & the prints had already given so correct an idea of it that I felt as if I was perfectly acquainted with it on the first glance".[15]

Between Durham and Newcastle the most notable features were Lumley Castle and, later, Lambton Castle. Lumley Castle, seat of the Earl of Scarbrough, was justly famous for its treasures known through the inventory of 1590.[16] Lambton Hall was gothicised and transformed into a castle in the 1820s when Lord Durham became the Earl of Lambton and, during the same period, Brancepeth Castle was turned into a gothic castle by Matthew Russell. Both these great northern Whig landowners were responding to the romantic revival and creating chivalric settings[17] for themselves. Both families had earned their fortunes from coal and this puts into context the charming anonymous water-colour, **Felicity Hunters entering Shiney Row in Search of the Picturesque, September 1828** (illus. p. 32). The pleasure-seeking ladies and gentlemen in the carriage were, perhaps, guests at Lambton Castle or Brancepeth Castle (the Lambton title was created in 1828) and are visiting the small pit village of Shiney Row which has never been a Picturesque site but was the basis of great profit from the local coal trade.

Newcastle is rarely described in Picturesque terms but was often praised for the modern developments of the 1820s. Earlier writers, however, are less flattering:

"We have no connection whatever with the coal trade and were never at Newcastle but once, passing through it on top of an exceedingly heavy coach, along with about a score of other travellers; nor, should we live a thousand years, is it possible we can forget that transit. We wonder what blockhead first built Newcastle; for before you can into and out of it, you must descend one hill, and ascend another about as steep as the sides of a coal pit. Had the coach been upset that day, instead of the day before, and the day after, there would have been no end, and indeed no beginning to this magazine. We were all clustered together as thickly together on the roof of the vehicle (it was a sort of macvey or fly) as the good people of Rome did to see Great Pompey passing along: but we, on the contrary, saw nothing but a lot of gaping inhabitants, who were momentarily expecting to see us all brought low. We remarked one man fastening his eye upon our legs that were dangling through from the roof under an iron rail who, we are confident was a **Surgeon**. However, we kept swinging along from side to side as if the macvey had been as drunk as an owl, and none of the passengers, we have reason to believe, were killed that day – it was a maiden circuit."[18]

Poetic language was reserved for the countryside north of Newcastle:

"A greater Luxuriance of picturesque scenery than in the Ride between Newcastle and Hexham, Eye cannot see nor Fancy paint and the awful Ruins of Prudhoe Castle pointing to the clouds its venerable Head make no small Addition to the Richness of the Prospect."[19]

William Pearson (1811–1872) the curate of North Rock, Cheshire, made a tour of Northumberland and Durham with his friend R. Atkinson, an amateur artist, between the 9th July and 3rd August 1838. They afterwards produced jointly "a Journal of an Excursion to Ye North of England A.D. 1838 Containing Partly: things true but not new; Partly: things new but not true."[20] Pearson was responsible for the text which was illustrated with Atkinson's rather naive sketches:

"the scenery of Tynedale is of a difficult character to describe, I shall therefore endeavour to do so by simile. Sometimes one sees a female face which at first sight does not strike you as possessing any particular beauty: it improves however on aquaintance, there is **a something** about it very pleasing and you find yourself half in love, without knowing exactly **with what**. Now it is just so with Tynedale: there is nothing particularly striking about it: but it

has a very **amiable** look: the more you see it the better you like it: like the lady above it pleases more perhaps by its **negative** than by its **positive** qualities: but it does not the less on that account steal the heart.''

Curiously, neither Bywell nor Brinkburn were obvious sites on the Picturesque tour. Samuel Hieronymous Grimm painted one of his most magnificent water-colours of Bywell; William Pearson certainly visited it:

"A little below Bywell, Mr Beaumont is building a handsome bridge. Still within a few years there were visible the remains of Norman Bridge near the site of the present one: but Mr Beaumont blew it up like a goth as he was. Now I think that a man who blows up any vestige or memorial of that fine people, he ought to be blown up himself for it: and if he has a wife I hope she did it for him.''[21]

Brinkburn is one of the most Picturesque sites in Northumberland and it is fitting that J. M. W. Turner painted a magnificent view of it (illus p. 90). Pearson again, although no expert, suggests a reason for its comparative lack of popularity:

"the view from the west is the finest: but the ruins are not sketchable from that point from want of foreground.''[22]

However, to one visitor it was "majestic Brinkburn, a Priory whose awful Ruins will ever be venerated by every Lover of Antiquity''[23] and "the learned antiquarians Hutchinson and Grose were both struck with admiration on viewing this priory and declared it was the most melancholy and solitary place for religious service and contemplation they ever visited''.[24]

Then to the coast. Lindisfarne "was also truly solemn by the awful prospect of the boisterous ocean'',[25] and its associations with St. Cuthbert made it a particular attraction. "The Monastery here is a noble Ruin and will by no means disappoint the Expectation of the Antiquarian Traveller''.[26] The castle of Lindisfarne is mentioned less frequently as there were only the ruins of a 16th century fort with gun emplacements until it was bought by the owner of **Country Life**, Edward Hudson, in 1902 and turned into a thoroughly romantic castle by the architect Sir Edwin Lutyens.

Bamburgh Castle was also not at its finest during this period and the buildings were in ruins when they were bought by Lord Crewe, the Bishop of Durham, in 1704. Crewe bequeathed his estates for charitable use and one of his trustees, Dr. Sharp, undertook to make the Keep habitable again in 1757 and installed in it a girls' school, an infirmary, a granary and accommodation for shipwrecked sailors. The "gothicising'' of the castle was undertaken by Lord Armstrong who bought the castle about 1890. However, Bamburgh's commanding position on the coast, Sublime when seen from the sea, and Picturesque when its ruins were viewed from the village, was a constant source of inspiration for artists. Writers were often more fascinated by the charitable work contained within its walls but Walter Scott made much of its medieval grandeur in his ballad **Marmion: a tale of Flodden Field**, 1808:

"Thy tower, proud Bamborough, mark'd
they there
King Ida's castle, huge and square
From its tall rock look grimly down
And on the swelling ocean frown.''

To unprepared visitors, it must have been an extraordinary experience to travel down the coast from Bamburgh Castle and to see Dunstanburgh Castle ahead. The first Duchess of Northumberland in a travel diary for 1760 expresses the effect that was so dramatically caught by a variety of artists:

"Tho almost entirely a ruin there is from its immense size & its situation on a high black perpendicular Rock over the sea which smashes three sides of it something stupendously magnificent in its appearance. The Grandeur of wch that Day was greatly augmented by a stormy N.E. wind wch made the Waves (mountain high) – foaming & roaring against its walls & made a scene of glorious horror & terrible Delight.''[27]

Most tours then went inland to Alnwick. Alnwick Castle was a constant source of interest, partly because of its antiquity and associations with the ancient family of Percy but also because of the lavish redecoration and restoration in the gothic style that was undertaken by Robert Adam in the 1760s. Huln Park with its Brislee Tower was turned into a Picturesque park full of follies and gothic delights:

"Next morning road thro' Huln Park the Grounds of which are laid out by the inimitable Brown; in the middle of the Park is an elegant and lofty

belvidere called Brissley Tower."[28]

In 1770 "the Man of Feeling" described Alnwick as having "the finest pleasure walks in England".[29]

Then to Warkworth, which, with its castle above the River Coquet and its Hermitage, was perhaps the most Picturesque of all Northumbrian sites. Dr. Thomas Percy published his collection of medieval verse, **The Reliques**, in 1765 and these were so popular that three editions appeared in ten years. Contained within **The Reliques** was a ballad written by Percy himself, **The Hermit of Warkworth**, a retelling of a medieval legend. The poem became famous and many visitors to Warkworth refer to it in their own descriptions:

"Not far from hence, where yon full stream,
Runs winding down the lea,
Fair Warkworth lifts her lofty towers,
And overlooks the sea."

"Those towers, alas! now stand forlorn,
With noisome weeds o'er spread,
Where feasted Lords and courtly Dames,
And where the poor were fed."

Dr. Johnson, however, wrote a splendid parody of it in 1779:

"Hermit hoar in solemn cell
Wearing out life's evening grey;
Smite thy bosom, sage, and tell,
What is bliss, and which the way?

Thus I spoke; and speaking sigh'd
Scarce repress'd the starting tear –
When the smiling sage repli'd –
'Come my Lord and drink some beer'".[30]

Percy's self-conscious medievalising certainly deserved its parody but Warkworth was a site redolent with history and atmosphere. Shakespeare had written of Warkworth Castle in Henry IV, part I, and so visitors were primed to be impressed and approached the Hermitage with a deference due to such an intensely Picturesque place. R. Warner wrote in 1802:

"half a mile up this romantic river is found the Hermitage to be visited in the boat which was kept by a man who lives in and shews the castle. The introduction to this sequestered spot, over the still surface of the gently winding river hemmed in by banks, where rock and wood, meadow and glade, present themselves in most picturesque combination, was extremely happy, and well calculated to encourage those tender emotions which the perusal of Percy's beautiful poem, that we carried in our hands awakened. Slowly rowing up the stream, (for its beauty were not to be passed hastily by) we at length landed on the holy ground, under a perpendicular face of rock, approaching so closely to the stream as to admit only a narrow path between the two. This is darkened by thickly planted trees, through whose shade we proceeded about one hundred yards, and found ourselves at the foot of a rude flight of stone steps over which a huge ash threw its broad shade, adding solemnity to the features around. Ascending them, we were conducted to a series of small apartments, the scene (as it is said) of the hermit's devotion . . . the hermit's residence was above these apartments, in a little stone edifice now dilapidated; and higher still lay his sequestered garden, running along a ledge of the rock and reached by a series of steps hewn out of its face; embosomed in trees and impervious to every human eye. It required no effort of the imagination (influenced by all the impressive accompaniments of the adjoining scenery) to picture the holy man in this his sacred retirement pacing the shaded walk and breathing out his soul."[31]

William Pearson provides us with the negative view:

"The situation of ye Hermitage is delightfully quiet & sequestered, close upon ye river: & I enjoyed it much & wd.have done much more had it not been for ye encumberance of ye stupid guide & two or three 'lions and lionesses' who crossed over in ye boat at ye same time with us."[32]

And lastly, Tynemouth.

After crossing the "horrid yet . . . pleasing" rocks Tracey Atkyns goes on to describe the Priory as "very fine ruins of an ancient monastery one of the finest religious foundations in England, the most beautiful gothic building that can be seen."[33] What did he think of Durham where he was staying? "The Cathedral is a large old Gothic building but nothing very memorable in it."[34]

A vast quantity of topographical poetry has been written about the North East, of varying quality. Most notable is the work of the Newcastle born poet Mark Akenside who in his poem **Early Influences**, published in the **Pleasures of Imagination**, 1772, writing of his native county, clearly reveals that mood of romanticism which culminates in Wordsworth's **Prelude**:

O ye Northumbrian shades, which overlook
The rocky pavement and the mossy falls
Of solitary Wensbeck's limpid stream;
How gladly I recall your well-known seats
Belov'd of old, and that delightful time
When all alone, for many a summer's day,
I wandered through your calm recesses, led
In silence by some powerful hand unseen.
 Nor will I e'er forget you, nor shall e'er
The graver tasks of manhood, or the advice
Of vulgar wisdom, move me to disclaim
Those studies which possess'd me in the dawn
Of life, and fix'd the colour of my mind
For every future year.

 Akenside, Pleasures of the Imagination
 (final version); cf. Wordsworth, Prelude
 VIII, 468, the 1786 and final versions
 (ed. De Selincourt).

Views of Northumberland and Durham

1. Leslie Parris, **Landscape in Britain, c. 1750-1850,** Tate Gallery, 1973, p. 75.
2. Celia Fiennes, **Through England on a Side Saddle,** 1st. ed., 1888.
3. Defoe, letter of c. 1725, quoted, Penguin ed. p. 537.
4. **Observations made during a Tour Through part of England, Scotland and Wales in a series of letters,** London, 1760.
5. Atkyns, **Iter Boreale,** YCBA.

6. MS 1080, NLS.
7. **The Letters of Mrs. Elizabeth Montagu,** vol. VI, 1813, p. 114 (to Benjamin Shillingfleet)
8. Atkyns, **Iter Boreale**, YCBA.
9. MS 2505, NLS.
10. quoted in Hussey, p. 92.
11. Thomas Gray, **Letters,** vol. 3.
12. Ibid.
13. MS 1080, NLS.
14. Elizabeth Burdon quoted in Bill Monck, **Castle Eden: an illustrated guide,** Peterlee Development Corporation, 1980, p. 29.
15. Adèle M. Holcolmb, **John Sell Cotman in the Cholmeley Archive,** North Yorkshire County Record Office, 1980, p. 25.
16. Walpole Society, vol. VI, pp. 15-46.
17. Mark Girouard, **The Return to Camelot: Chivalry and the English Gentleman,** Yale, 1981, p. 69.
18. quoted in James Murray, **The Travels of the Imagination; a true journey from Newcastle to London in a stage coach with observations made upon the Metropolis,** Newcastle, 1828.
19. MS 1080, NLS.
20. Pearson, p. 164.
21. Ibid.
22. Ibid.
23. MS 1080, NLS.
24. Scott, 1821, p. 28.
25. Ibid, p. 52.
26. MS 1080, NLS.
27. quoted by Victoria Percy and Gervase Jackson – Stops, Country Life, 14th February 1974.
28. MS 1080, NLS.
29. MS 22. 5.3, NLS.
30. quoted in E.F. Carritt, **A Calendar of Taste,** 1600-1800, p. 368.
31. **A Tour Through the Northern Counties of England and the borders of Scotland,** 1802, vol. II, p. 13.
32. Pearson, p. 99.
33. Atkyns, **Iter Boreale,** YCBA.
34. Ibid.

Catalogue

The Amateurs

Amateur artists at this period are an interesting study on several levels.

Among the aristocracy, skill with the pencil and water-colour brush was considered an important social accomplishment. The following advertisement was placed by the Society of Arts in the **Gentleman's Magazine** of 1790:

HONORARY PREMIUMS FOR DRAWINGS

169	For the best Drawing by sons or grandsons of Peers or Peeresses of Great Britain and Ireland, to be produced on the first Tuesday in March, 1791; the gold medal.
170	For the second in merit: the silver medal.
171, 172	The same premiums will be given to daughters or grand-daughters of peers or peeresses of Great Britain and Ireland.

As painters, amateurs reflect the ideas of their drawing masters, rarely producing anything more individual, but indicating what the professional eye saw as worth selecting and emphasising. As patrons, however, they not only introduced artists to new landscapes and areas of interest but through commissions and purchases directed the course of an artist's work. Within Northumberland and Durham the most influential patrons, as far as water-colour painters are concerned, appear to have been the Swinburnes of Capheaton, William Ord of Whitfield and the Countess of Tankerville at Chillingham. Such families led active lives in London, maintaining houses there and employing artists as drawing masters in both areas of the country.

Sir John Edward Swinburne (1762–1860) was a major figure in the London art world, a founder of the Artists' Benevolent Fund, Fellow of the Royal Society, Fellow of the Society of Antiquaries and a Member of the Royal Society of Literature. He was also President of the Newcastle Literary and Philosophical Society and the Newcastle Society of Antiquaries, and a patron of Turner, Callcott and Mulready. The Swinburnes were Catholics, like the Fawkes family of North Yorkshire, Turner's greatest patrons, and this may have facilitated Turner's introduction to the North East. Edward Swinburne (1765–1847), Sir John's younger brother who lived at Capheaton from 1829, was an amateur artist but with considerable talent and was taught by Turner. Edward Swinburne supplied many of the illustrations to Hodgson's **History of Northumberland** and Surtees' **History of Durham**. A cousin of the family, Julia Gordon, née Bennet, was taught by Turner, probably Girtin and later by David Cox. Clearly, through their relations and their friends, the Swinburnes moved in an artistic milieu. They were certainly acquainted with the Cholmeleys of Brandsby who were friends and patrons of John Sell Cotman. Teresa Cholmeley wrote to her husband from Capheaton on 7th August 1805:

"We got here on Monday at 4 o'clock, fearing we might hardly be in time for dinner. No body was within. We ask(e)d the dining hour? **Half past six**. Sir J(ohn) & L(ad)y and S(winburne) soon appear(e)d & we had a long walk before dinner. We have found Macklin here as also Edw(ar)d senior & Edw(ar)d junior. Nothing could be kinder than our reception and no house can be fuller of varied amusements such as suit and delight me. The books, drawings and prints are endless and admirable. Oh, how I wish Cotty could see all Edw(ar)d S(winburne)'s drawings. Most of them are excellent indeed and I hardly know in what he succeeds the best. Some of his late sea and rock studies are admirable. So are his trees. I often wish we were all here together, for the pleasure and improvement of all parties, but I do anxiously hope Cotty will not relax of his industry and draw and tint perseveringly from nature. I do so wish he could see Swinburne's **trees**, and was more acquainted w(it)h Swinburne himself, whose taste and knowledge and experience are certainly all of the highest class, with the gentlest and most pleasing manners. He has one glorious drawing of Girton's (sic) and a fine one of Varley's."

William Ord (1781–1855) of Whitfield was a patron and a pupil of John Varley. He bought several works by Varley from the OW-CS exhibitions and also a view of Newcastle upon Tyne, 1808 (cat. no. 135). Ord also received drawing lessons from Varley and painted several compositions in the Varley manner on his continental tours between 1814 and 1816.

Emma, Countess of Tankerville (1752–1836) was described by Thomas Creevey (who had married William Ord's widow): "(she) has perhaps as much merit as any woman in England . . . very clever and has great wit". The Countess appears to have employed Varley both at her London villa at Walton-on-Thames and at Chillingham. He certainly appears to have been employed as a drawing master in Northumberland to her daughter Lady Mary Bennett, who later married Sir Charles Middleton, 5th Bt. of Belsay, and owned drawings by Varley and made her own compositions and sketches in his manner. Sir

Charles' first wife was Cecilia Priscilla Cooke of Doncaster whose tuition in drawing was in the style of the early topographers, like that received by Margaret Davidson whose distant view of Newcastle upon Tyne (cat. no. 13) was previously attributed to Thomas Hearne. Margaret Davidson may perhaps be related to Martha Davidson, whose views of Ridley Hall, Northumberland, were recently discovered (see Nancy Ridley, **A Northumbrian at large**, 1975, pp. 87–93).

In this context it is interesting to read a letter from Thomas Gray written from Old Park, near Darlington, to his friend Mason on the 9th August, 1767:

"The Doctor presents his compliments to you with great cordiality and desires your assistance. One of his daughters has a turn for drawing, and he would wish her a little instructed in the practice. If you have any Professor of the Art at York that would think it worth his while to pass about six weeks here he would be glad to receive him. His conditions he would learn from you. If he has any merit in his art, doubtless so much the better. But above all he must be elderly, and if ugly and ill-made so much the more acceptable. The reasons we leave to your prudence."

1
Edward Swinburne
Belsay Castle
pencil, wash, pen and ink
240 x 340
inscribed on reverse:
> Belsay Castle . Northumberland/
> The original drawing by **Edward**
> **Swinburne**/of Capheaton/For
> Neale's Views London. Publ. 1819
> by J.P. Neale.

prov: Sir Stephen Middleton, by whom
> given to the Laing Art Gallery, 1962
Laing Art Gallery, Tyne and Wear County
Council Museums.

Published in J.P. Neale's **Views of the**
Seats of Noblemen and Gentlemen in
England, Wales, Scotland and Ireland
1818-23.

2
Fawdon Staithe on the Tyne
pencil, wash, pen and ink
125 x 177
prov: John Hodgson, by whom
> bequeathed to the Library of the
> Society of Antiquaries, Newcastle
> upon Tyne, 1926
Library of the Society of Antiquaries of
Newcastle upon Tyne.

A drawing for the aquatint in Hodgson's
History of Northumberland.
(see no. 3 below)

3
Haughton Castle
watercolour
102 x 228 (sight)
prov: by descent
Private collection.

4
Newcastle upon Tyne
aquatint
143 x 185 (image)
prov: J. Hodgson, by whom bequeathed
> to the Library of the Society of
> Antiquaries of Newcastle upon
> Tyne, 1926
Library of the Society of Antiquaries of
Newcastle upon Tyne.

Contained in album with various studies
for and prints from Hodgson's
History of Northumberland, displayed
together with no. 2 above.

5
Member of the Swinburne family
Portrait of Edward Swinburne
watercolour
oval, 101 (height)
prov: by descent
Private collection

6
Lady Mary Monck
Cottage in a clearing
watercolour and bodycolour
103 x 181
inscribed on reverse:
Lady Mary Monck
prov: by descent
Private collection.

A heavily laboured and unsuccessful
drawing, probably before Varley's
instruction. The influence of 'techniques'
is obvious: thick bodycolour and
extensive scratching out.

7
An illustrated memorandum
containing twelve watercolours, and
pencil sketches open at a view on a
lake shore.
151 x 115
inscribed, inside cover:
> mem::dums of a short tour in
> Scotland with my brother, Lord
> Tankerville, 1826.
prov: by descent
Private collection.

8
Composition
watercolour and pencil
137 x 188
inscribed reverse:
> composition/Varley
prov: by descent
Private collection.

A classical landscape in the Varley
'composition' manner.

9
Cecilia Priscilla Cooke
Durham Cathedral
watercolour and pencil and pen and ink
273 x 356
Signed, lower right margin: C.P. Cooke
prov: by descent
Private collection.

10
British School, C18
View of Alnwick Castle from
The Gardens
watercolour and pen and ink
216 x 272 (irregular)
prov: Harold Hill, from whom
> purchased by the Laing Art
> Gallery, 1935.
Laing Art Gallery, Tyne and Wear
County Council Museums.

11
British School, C18
View of the First Court of
Alnwick Castle
watercolour and pen and ink
213 x 275 (irregular)
prov: Harold Hill, from whom
 purchased by the Laing Art
 Gallery, 1935.
Laing Art Gallery, Tyne and Wear
County Council Museums.

Two amateur views of Alnwick Castle
drawn after Robert Adam's 'gothicising'
of the 1760's. Pennant in his **Tour of the
North** had written critically of the money-
grasping staff at Alnwick and subsequent
writers were eager to refute this unfair
claim: 'I am happy to inform the Reader
that there comes a Valet ready to show a
stranger every Curiosity'.
These views show Picturesque Tourists
being shown the curiosities: one figure
carries his guide or sketchbook under
his arm.

12
William Gilpin (1724-1804)
Mountainous landscape
sepia wash
132 x 182
exh: Carlisle Art Gallery, 1971,
 Cumberland Artists 1700-1900, (1)
prov: Arthur Rogers; from whom
 purchased by the Laing Art
 Gallery, 1935
Laing Art Gallery, Tyne and Wear County
Council Museums.

Illustrative of Gilpin's own description:
"cheifly imaginary and seldom went
beyond the idea of rough sketches."

13
Margaret Davidson
Distant View of Newcastle upon Tyne
1802
watercolour
365 x 480
inscribed, on reverse of old mount:
 Margt Davidson
 May 28
 1802
prov: W.B. Reid, Esq., by whom given to
 the Laing Art Gallery in 1915
Laing Art Gallery, Tyne and Wear County
Council Museums.

14
British School, early C19
**Felicity Hunters entering Shiney Row
in search of the Picturesque**
1828
watercolour and pencil
200 x 225
inscribed, centre: Felicity Hunters/
 entering Shiney Row / in search of
 the Picturesque / September 1828
prov: Abbott & Holder; Caroline Smyth,
 from whom purchased by the
 present owner, 1981
Private collection.

Illus. p. 32
An amusing comment on the fashion for
Picturesque tours: the party has
presumably come from one of the large
Durham houses to see a 'quaint'
pit-village.

Thomas Allom (1804-72)
Allom was born in London and articled
to Francis Goodwin, the architect, and
studied at the Royal Academy Schools.
Although he was a successful architect
and a founder member of the Royal
Institute of British Architects, Allom is

best known now for his extensive
output of topographical drawings in
Britain, Europe and Asia.
One of his major commissions was for
Rose's **Views in Westmorland,
Cumberland, Durham and
Northumberland,** 1839. His minutely
detailed sepia drawings for this
publication have a delicacy not always
associated with the later topographers
and their steel engravings (see also
George Balmer).

15
Bishop's Palace, Bishop Auckland
pencil and sepia wash
98 x 156
prov: Walker's Galleries, from whom
 purchased by Sunderland Art
 Gallery, 1960.
Sunderland Art Gallery, Tyne and Wear
County Council Museums.

Engraved by S. Lacey for Thomas Rose's
Durham and Northumberland, p. 66.

16
Stanhope Castle
pencil and sepia wash
97 x 153
inscribed, lower left and margin:
 T. Allom / Stanhope Castle
 Durham
prov: Walter Bennett, from whom
 purchased by the Laing Art
 Gallery, 1936.
Laing Art Gallery, Tyne and Wear
County Council Museums.
Engraved by W.H. Capone for Thomas
Rose's **Durham and Northumberland**
p. 85.

17
J. Redway, after Thomas Allom
The Grotto in Castle Eden Dene
coloured engraving
98 x 151 (image)
Private collection.

Published in Thomas Rose's **Durham and Northumberland**, p. 22.

Joseph Atkinson (1776-1816)
Born in Newcastle, Atkinson's work is almost exclusively known through his image of Tanfield Arch. The subject was commissioned as an oil painting by Sir Matthew White Ridley which was aquatinted after Atkinson's death by J.C. Stadler for the benefit of the artist's widow and children.

18
Tanfield Arch, Co. Durham
c. 1804
watercolour
425 x 590
prov: Frank T. Sabin, from whom
 purchased by the Science
 Museum. 1956
Science Museum (Pictorial Collection),
Science Museum Library.

A 20th century note on the backing paper reads: 'This is the sketch for the original picture painted by Atkinson upon a commission from Sir Matthew White Ridley, 2nd Bart of Blagdon, Northumberland. He appears in the foreground gun in hand with his dogs and gamekeeper'. Tanfield Arch was built in 1727.

19
J.C. Stadler after Joseph Atkinson
Tanfield Arch, Co. Durham.
c. 1816
aquatint
494 x 640 (plate mark)
prov: Frank T. Sabin, from whom
 purchased by the Laing Art
 Gallery, 1955.
Laing Art Gallery, Tyne and Wear County
Council Museums.

George Balmer (c. 1806-1846)
The son of a North Shields house-painter Balmer began his career as a decorator in Edinburgh and started to work in water-colour. He lived for a while in Newcastle upon Tyne but after a prolonged European tour settled in London.
In 1838 he began publication of **The Ports, Harbours, Watering-Places and Coast Scenery of Great Britain,** with E. and W. Finden. This was extended in 1842, again in 1872 and was one of the most popular steel-engraved topographical publications. Balmer and Allom (q.v.) are included as representatives of the later topographers who placed particular emphasis in their work on the North-East landscape.

20
Tynemouth Castle
1835
watercolour
268 x 348
dated, lower left: 1835
repr: Hardie, III, pl. 95
prov: Wm. Smith, by whom bequeathed
 to the Victoria and Albert Museum.

Engraved by Edward Finden for **Views of Ports, Harbours and Watering-Places and Picturesque Scenery of Great Britain,** vol. 1, 1838 and published as 'Tynemouth Castle: vessel wrecked on the rocks.'

21
Newcastle upon Tyne
c. 1835
watercolour and bodycolour
230 x 335
prov: W.W. Sampson, from whom
 purchased by the Laing Art Gallery,
 1927.
Laing Art Gallery, Tyne and Wear County
Council Museums.
Engraved as above. Illus. p. 46.

William Brown (fl. c. 1795-1809)
Almost certainly the William Brown who exhibited architectural drawings at the Royal Academy, 1801-1809. A drawing master at Durham who worked in a naive style but whose drawings of local Picturesque scenes were published in London.

22
Durham, from the lower end of Framwellgate
c. 1809
sepia with pen outlines
219 x 358
prov: purchased by the British Museum,
 1877
British Museum.

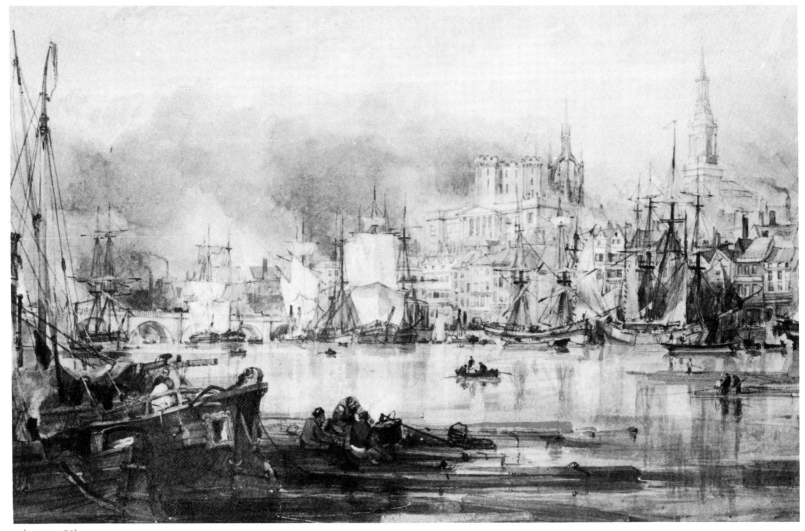

(cat. no. 21)

23

Maiden Castle Scar, near Durham
c. 1809
sepia with pen outlines
212 x 342
prov: purchased by the British Museum,
 1877
British Museum.

24

**F. Jukes and Sarjent, after
William Brown
Maiden Castle Scar, near Durham**
1809
aquatint
217 x 340 (image)
Sunderland Art Gallery, Tyne and Wear
County Council Museums.

25

**F. Jukes and Sarjent after
William Brown
Durham, from the lower end
of Framwellgate**
1809
aquatint
265 x 365 (plate mark)
prov: John George Joicey, by whom
 bequeathed to the Laing Art
 Gallery, 1919
Laing Art Gallery, Tyne and Wear County
Council Museums.

F.B. (fl. C18)
An unidentified artist, possibly a drawing
master, whose work is reminiscent of that
of William Brown (q.v.). The figure in
the foreground is pausing to admire
the view.

26

Durham from the North-West
c. 1790
watercolour and pen and ink
130 x 200
initialled, lower left: F.B.
inscribed, centre margin: Durham
prov: purchased
Sunderland Art Gallery, Tyne and Wear
County Council Museums.

**Samuel Buck (1696-1799) and
Nathaniel Buck (? – before 1779)**
From 1711-1726 Samuel Buck worked
as both draughtsman and engraver on a
huge project to depict four hundred and
twenty eight views of the ruins of all the
notable abbeys, castles etc., in England
and Wales together with views of
country seats and eighty three general
views of the principal cities. From 1727-
1753 he was assisted in both branches
of his work by his brother Nathaniel
who predeceased him by several years.
Their views of Northumberland and
Durham were published in 1728.
Samuel Buck's drawings were
sometimes slight and hasty but many
were elaborately finished with pen and
ink and tinting. Some of these were
exhibited with the Society of Artists and
the Free Society between 1761-1775
and at the Royal Academy in 1775.
The D.N.B. says of Samuel "As a
painstaking delineator of architectural
remains long since destroyed Buck has
never been surpassed for truthfulness of
detail, often conveyed with the sacrifice
of general effect."

27

**The South-West View of
Brinkburn Priory**
1728
etching
194 x 375 (plate mark)
prov: Mr. Rae, by whom given to the
 Laing Art Gallery, 1951
Laing Art Gallery, Tyne and Wear County
Council Museums.

28

**The South-West View of
Dunstanburgh Castle**
1728
etching
195 x 378 (plate mark)
prov: Mr. Rae, by whom given to the
 Laing Art Gallery, 1951
Laing Art Gallery, Tyne and Wear County
Council Museums.

29

**The South-West View of
Bamburgh Castle**
1728
etching
191 x 373 (plate mark)
prov: Mr. Rae, by whom given to the
 Laing Art Gallery, 1951
Laing Art Gallery, Tyne and Wear County
Council Museums.

THE SOUTH VIEW OF WARKWORTH CASTLE, IN NORTHUMBERLAND.

(cat. no. 30)

30
The South View of Warkworth Castle
1728
etching
194 x 373 (plate mark)
prov: Mr. Rae, by whom given to the Laing Art Gallery, 1951
Laing Art Gallery, Tyne and Wear County Council Museums.
Illus. above.

31
The West View of Barnard Castle
1728
etching
191 x 374 (plate mark)
prov: Mr. Rae, by whom given to the Laing Art Gallery, 1951
Laing Art Gallery, Tyne and Wear County Council Museums.

32
The South View of Holy Island Monastery and Castle
1728
etching
193 x 378 (plate mark)
prov: Mr. Rae, by whom given to the Laing Art Gallery, 1951
Laing Art Gallery, Tyne and Wear County Council Museums.

33

The West View of Finchale Priory
1728
etching
194 x 373 (plate mark)
prov: Mr. Rae, by whom given to the
 Laing Art Gallery, 1951
Laing Art Gallery, Tyne and Wear County
Council Museums.

34

The South-East View of Raby Castle
1728
pen and ink
154 x 350
inscribed, top right: lune. 1728
prov: W.H.D. Longstaffe, from whom
 acquired by the Dean and Chapter
 of Durham
Dean and Chapter of Durham.

35

The South East View of Raby Castle
1728
etching
193 x 375 (plate mark)
prov: Mr. Rae, by whom given to the
 Laing Art Gallery, 1951
Laing Art Gallery, Tyne and Wear
County Council Museums.

This set of views was produced in 1728,
early in the undertaking to illustrate 'the
venerable remains of above four
hundred Castles, Monasteries, Palaces,
etc., in England and Wales.' The early
prints are not as sophisticated as
subsequent ones which contain elegant
figures and small incidents. There is little
development from the work of Francis
Place (q.v.) apart from a shift in vision from
the general to the particular.

John Chessell Buckler (1793-1804)
Son of John Buckler who was also a
prolific antiquarian draughtsman, J.C.
Buckler worked on building restoration,
especially in Oxford. Father and son
often travelled together on drawing
tours and their work is frequently
confused.

36

Barnard Castle
1817
watercolour
171 x 254
signed and dated, lower right:
J.C. Buckler 1817
prov: Bernard Halliday, from whom
 purchased by the Bowes Museum,
 1938
The Bowes Museum, Barnard Castle,
Co. Durham.

Augustus Wall Callcott (1779-1845)
Callcott was elected a member of the
Royal Acadamy in 1810, replacing Paul
Sandby. This biographical detail
exemplifies an aspect of his career in
which Callcott represents the second
generation of Picturesque landscape
painters whose blend of topography and
romantic scenes owes as much to
Turner as to Claude. Callcott wrote
perceptively: "Our taste has a kind of
sensuality about it as well as love of the
sublime."
Sir John and Lady Swinburne of
Capheaton, Northumberland, were
important patrons to both Turner and
Callcott and it is possible that Turner
effected the introduction. Callcott's first
exhibited Italian subject, **The
Fountain: Morning** was painted for

Lady Swinburne and, in 1818, he
exhibited an oil painting of **The Mouth
of the Tyne** (whereabouts unknown).

37

Paper Mill below Haughton Castle
1815
watercolour
304 x 457 (sight)
signed and dated, lower left:
1815/AWC
prov: Sir John Edward Swinburne;
 by descent
Private collection.

49

Luke Clennell (1781-1840)

Clennell was born at Ulgham, near Morpeth in Northumberland and was apprenticed to the wood engraver Thomas Bewick from 1797 when Bewick was working on his **History of British Birds.**

Clennell contributed several tail piece vignettes to the second volume and also produced a number of very fine watercolours of local scenes, including Bywell, during his apprenticeship. Clennell moved to London in 1804 where he worked not only as a wood engraver but as a designer for other engravers and began to exhibit watercolours. In 1811, he was commissioned to produce sixty of the illustrations to **The Border Antiquities of England and Scotland**; "comprising specimens of architecture and sculpture, and other vestiges of former ages, accompanied by descriptions. Together with illustrations of remarkable incidents in Border history and tradition and original poetry by Walter Scott." This was published between 1814 and 1817 in two volumes with copper engravings by J. Greig (fl. 1800-1815).

Although locally born, Clennell is included here as he did not reach maturity as a water-colourist until he lived in London for several years. It seems likely that he visited Northumberland and the lowlands of Scotland to make sketches for the book in 1811, and, in making a return visit in search of antiquities and scenery, should be classed as a "Picturesque tourist."

Tragically, Clennell was not able to develop his talents as a painter as he lost his sanity in 1817 and remained in asylums until his death.

38
Bywell Castle and ruins of the bridge
watercolour
260 x 419
signed, lower left margin: Clennell
prov: Harold Hill, from whom purchased by Laing Art Gallery, 1937
Laing Art Gallery, Tyne and Wear County Council Museums.

39
Anglers on the Tyne at Bywell
pencil and watercolour
216 x 327
signed, old mount, lower left: L. Clennell
prov: A.H. Higginbottom; purchased from his executors by the Laing Art Gallery, 1935
Laing Art Gallery, Tyne and Wear County Council Museums.
Illus. below.

40
Mitford Manor House
pencil and watercolour
251 x 352
prov: Trustees of the Walker Mechanics' Institute; by whom given to the Laing Art Gallery, 1932
Laing Art Gallery, Tyne and Wear County Council Museums.

Engraved for **Border Antiquities of England and Scotland,** Longman and Co., 1814 vol. 1, opp. p. 72 First published 1st August 1814.

(cat. no. 39)

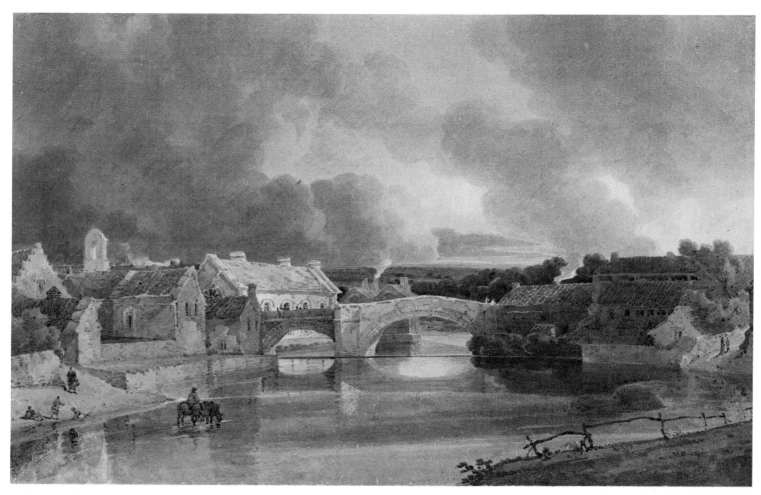

(cat. no. 89)

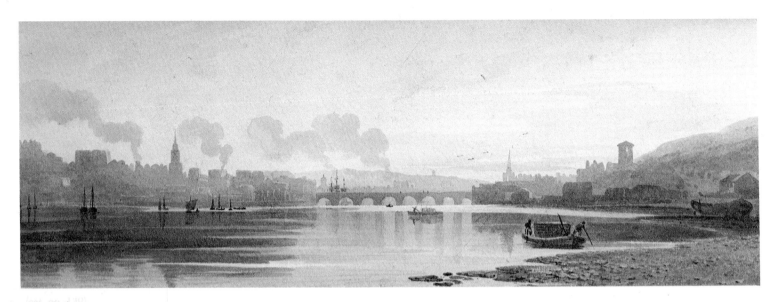

(cat. no. 140)

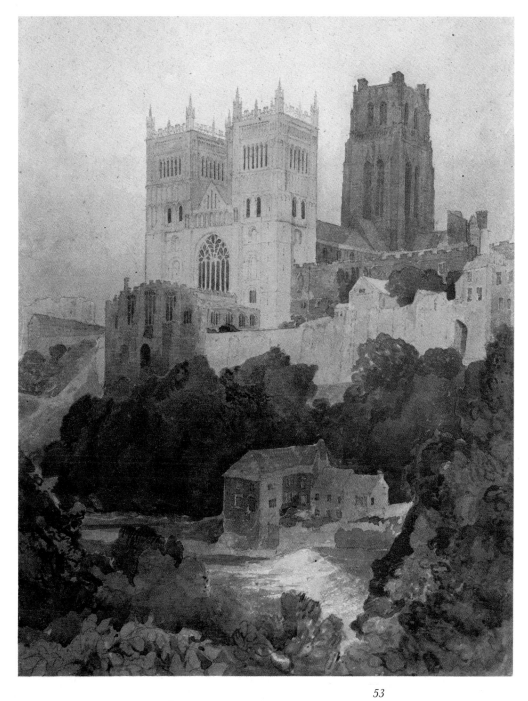

(cat. no. 47)

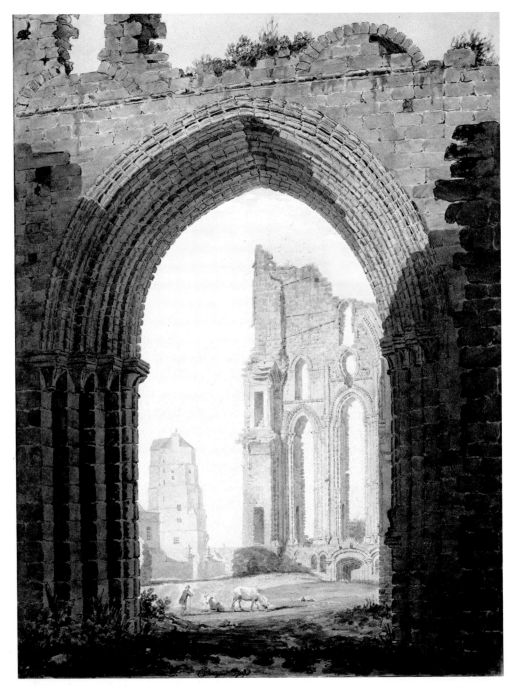

(cat. no. 57)

41

Tynemouth Priory
pencil and watercolour
281 x 261
prov: given to the Laing Art Gallery by
 Hugh Wilson, 1933
Laing Art Gallery, Tyne and Wear County
Council Museums.

Engraved for **Border Antiquities of
England and Scotland**, Longman and
Co., 1814, vol. 1, opp. p. 59. First
published 1st September 1813

42

Bywell Castle
pencil and watercolour
206 x 292
ref: Iain Bain, Thomas Bewick, an
 illustrated record of his life and
 work, Tyne and Wear County
 Council, 1979, p. 101, fig. 246
prov: Norman D. Newall, from whom
 purchased by the Laing Art
 Gallery, 1942
Laing Art Gallery, Tyne and Wear County
Council Museums.

Engraved for **Border Antiquities of
England and Scotland**, Longman and
Co., 1814, vol. 11. opp. p. 115. First
published 1st August 1814.

43

Warkworth Hermitage
penicl and watercolour
288 x 246
prov: J. Collingwood Stewart; Arthur
 Rogers, Newcastle upon Tyne,
 from whom purchased by the
 Laing Art Gallery under the terms
 of the John Wigham Richardson

bequest, 1956.
Laing Art Gallery, Tyne and Wear County
Council Museums.

Engraved for **Border Antiquities of
England and Scotland**, Longman and
Co., 1814, vol. 1, opp. p. 20. First
published 1st January 1815.

44

Warkworth Hermitage
pencil and watercolour
210 x 302
prov: J. Collingwood Stewart; Arthur
 Rogers, Newcastle upon Tyne,
 from whom purchased by the
 Laing Art Gallery, under the terms
 of the John Wigham Richardson
 bequest, 1956
Laing Art Gallery, Tyne and Wear County
Council Museums.

Although clearly related to the **Border
Antiquities** series this particular view of
Warkworth Hermitage was not engraved.

45

Lindisfarne Abbey: West front
pencil and watercolour
213 x 284
prov: J. Collingwood Stewart; Arthur
 Rogers, Newcastle upon Tyne,
 from whom purchased by the
 Laing Art Gallery, under the terms
 of the John Wigham Richardson
 bequest, 1956
Laing Art Gallery, Tyne and Wear County
Council Museums.

Engraved for **Border Antiquities of
England and Scotland**, Longman and
Co., 1814, vol. 11, opp. p. 134. First
published 1st March 1814.

46

Tynemouth Priory
pencil and watercolour
476 x 367
prov: Miss A.J. Thompson by whom
 bequeathed to the Laing Art
 Gallery, 1945.
Laing Art Gallery, Tyne and Wear County
Council Museums.

Although clearly related to the **Border
Antiquities of England and Scotland**
series this particular view of Tynemouth
was not engraved.

John Sell Cotman (1782-1842)

Born in Norwich, Cotman became a major figure in the "Norwich School" of artists and drawing masters. The leading member was John Crome, who, like Gainsborough, derived his inspiration for the painting of the East Anglian landscape from the example of seventeenth century Dutch painters. Cotman, however, brought to water-colour a new refinement and classicism created by his clarity and simplicity of line and colour.

Cotman's first sketching tour was to Wales in 1800 in the company of Paul Sandby Munn and in 1803 the two artists went north and stayed with the Cholmeley family at Brandsby, North Yorkshire. Cotman returned to Brandsby in 1805, and only after gentle persistence on the part of Mrs. Cholmeley did he visit Durham at all. He spent at least a week there, eventually, after obstinately writing to Francis Cholmeley from Greta Bridge on the 29th August 1805 "... the interest are in my storming Durham... but seriously what I have to do with Durham? am I to place it on my studies of trees like a Rookery. No and besides I have no time for Durham I want to get to Ray Wood – Durham I may take next Year as I most probably shall be at the Lakes and at Rokeby too..."

However, by Wednesday 4th September he had arrived in Durham and wrote to Francis Cholmeley two days later from Shotton's Inn, outlining how he had narrowly missed the Cholmeley family: "not expecting me though they so much pressed my coming... from Greta Bridge (the last post) told them I should not visit Durham at all – but I was in despair, and arrived here but a few Hours after they left it and within a mile of meeting them. It rained the whole of that Day and all Night (and at 4 & 5 Mng. in Torrents) till about 11. It then cleared and has since been delightful. It is a delightfully situated City – I have made but one outline since I have been here to my shame but I hope to be more industrious... I will wait here a week for you from this date... only should it suit you, indeed I shall be most happy to see you – the Hoares are from Durham but are to return on Sunday when I shall pay my respects. If you have not seen Durham return this Road by **all means** ..."

Between the 6th and the 14th, September when he returned to Brandsby, Cotman visited Castle Eden Dene in Co. Durham.

Kitson suggests that Cotman made a trip to Northumberland in 1808 which Rajnai does not accept: there appears to be no substantiation for the claim. Rajnai states that the only possible time for a visit to Northumberland was in September 1805, between the 6th and 14th which period included Cotman's visit to Castle Eden. At the time, the Cholmeleys were staying with the Charltons at Hesleyside and the Selbys at Biddlestone. There are however two drawings in YCBA, one signed and dated 1808, the other a slight sketch, both of Bamburgh. (B. 1975, 4. 184 and 1080). See illus. p. 58.

47
Durham Cathedral

1805
watercolour
438 x 333
exh: ? R.A. 1806 (41)
 ? Norwich Society, 1807 (18)
ref: Kitson, pp. 85 and 95
 Rajnai and Allthorpe-Guyton, p. 78
repr: Kitson, pl. 36
prov: Dawson Turner, his sale, Puttick and Simpson, 1859 at which purchased by the British Museum.
British Museum.
Illus. p. 57.

Cotman wrote to his patron Dawson Turner, and the first owner of this water-colour, on November 30th, 1805: 'My tour this summer has been confined to York and Durham. The Cathedral of the latter magnificent, tho' not so fine as that of York. – My chief study has been colouring from Nature many of which are close copies of that fickle Dame consequently valuable on that account.'

48
Castle Eden Dene

1805
black chalk and indian ink on grey paper
210 x 234
ref: Kitson, pp. 87 and 95
prov: James Reeve, from whom purchased by The British Museum, 1902
British Museum.

A sketch for the watercolour now in the National Gallery of Scotland. A note on the old mount by J.J. Cotman dates this drawing to early 1813-4.

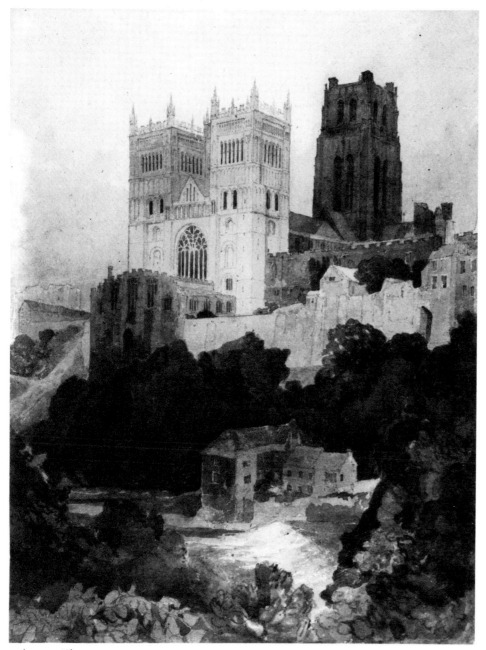

(cat. no 47)

49

The New Bridge, Durham
c. 1805
black and white chalk on grey paper
311 x 260
ref: Rajnai and Allthorpe-Guyton, p.78
repr: Reinaecker, pl. 22, fig. 39
prov: Sir Michael Sadler; Messrs. Spink
 from whom purchased by the
 Fitzwilliam Museum, 1949
Fitzwilliam Museum.

Sketch for watercolour in Sir Edmund Bacon s collection.

50

Chillingham
pencil
108 x 158
inscr., recto and verso: Chillingham
prov: Muskett – Orpen collection;
 Sydney D. Kitson, by whom
 bequeathed to Leeds City Art
 Galleries, 1938.
Leeds City Art Galleries

51

Butterby Gate House, Durham
soft ground etching
303 x 224 (plate mark)
ref: Popham, p. 271
 Russell, p. 158
prov: Craddock and Barnard, from
 whom purchased by Sunderland
 Art Gallery, 1974
Sunderland Art Gallery, Tyne and Wear County Council Museums.

Both etchings were published H.G. Bohn in **Liber Studiorum**, first as a separate work and then in his collected edition of Cotman's etchings in 1838. The name and the inspiration clearly came from

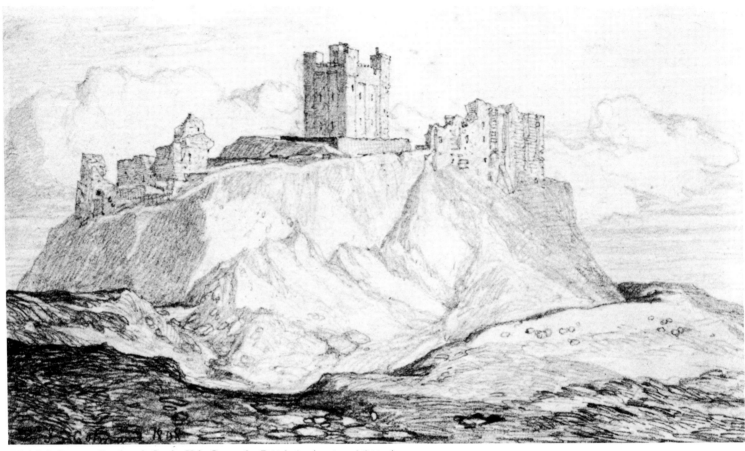

John Sell Cotman, Bamburgh Castle, Yale Center for British Art (not in exhibition)

Turner; Bohn said Cotman made his
etchings 'more for practice and
amusement'.

52
Bamburgh Castle
soft ground etching
113 x 200 (plate mark)
ref: Popham, pp. 271
 Kitson, pp. 125 & 137
 Russell, p. 158
repr: Kitson, pl. 62
prov: Craddock and Barnard, from
 whom purchased by Sunderland
 Art Gallery, 1974
Sunderland Art Gallery, Tyne and Wear
County Council Museums.

The sketch for the etching is in the Yale
Center for British Art (B. 1975.4.184),
and illus. above.

William Daniell (1769-1837)

Daniell, and his uncle Thomas Daniell, travelled to India and China publishing as a result the six volume **Oriental Scenery** between 1795 and 1808. William became a Royal Academician on the strength of his oil paintings but earned most of his living as a water-colourist and etcher in aquatint. His view of Durham Cathedral, 1805 (no. 53 below) is a splendid example of his exhibition water-colours.

His most ambitious enterprise was his **Voyage around Great Britain... by Richard Ayrton, with a series of views... drawn and engraved by William Daniell, A.R.A.** This appeared in series, eight volumes between 1814 and 1825, and contains 308 colour plates of Picturesque sites around the whole coast of Great Britain. Daniell and Ayrton, who was responsible for the text, travelled each summer and completed their work during each winter. The North East subjects, drawn between August and September 1821, are:

 207 Castle on Holy Island,
 Northumberland.
 208 Bamburgh Castle,
 Northumberland.
 209 North Shields, Northumberland.
 210 Tynemouth, Northumberland.
 211 Sunderland Pier, Durham.

Sutton points out "It is interesting to note that from North Shields onward there is a certain "modishness" in their presentation, the opportunity being taken to introduce small groups of figures in the attractive Regency costume."

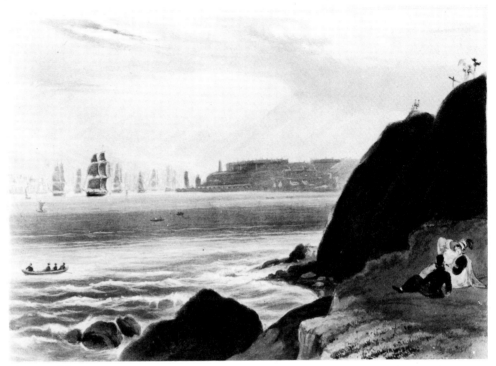

(cat. no. 54)

53

Durham Cathedral
1805
watercolour
400 x 650
signed and dated,
repr: Cosmo Monkhouse, **The earlier English water-colour painters**, 1890, facing p. 118
 N. Lytton, **Watercolours**, 1911, pl. 2.
ref: Hardie, III, pl. 60 & p.46
prov: William Smith, by whom given to the Victoria and Albert Museum, 1871
Victoria and Albert Museum.

Hardie describes no. 53 as 'a broad and powerful drawing, showing him a worthy successor to Girtin in choice of subject, colour and handling;

54

North Shields
coloured aquatint
22 x 298
prov: Sir George Renwick Bt., by whom given to the Laing Art Gallery, 1924
Laing Art Gallery, Tyne and Wear County Council Museums.
Illus. above.

55

Bamburgh Castle
coloured aquatint
228 x 298
prov: Sir George Renwick Bt., by whom
 given to the Laing Art Gallery, 1924,
Laing Art Gallery, Tyne and Wear County
Council Museums.

56

Tynemouth
coloured aquatint
228 x 298
prov: Sir George Berwick Bt., by whom
 given to the Laing Art Gallery,
 1924
Laing Art Gallery, Tyne and Wear County
Council Museums.

All drawn and etched by Daniell and
published by him on 1st July 1822.

Edward Dayes (1763-1804)
Dayes trained first as a mezzotinter and
then studied at the Royal Academy
Schools. He worked as a miniaturist
and painter of subject pictures but is
best known for his work as a
topographer. He wrote **An Excursion
through Derbyshire and Yorkshire**
and **Instructions for Drawing and
Colouring Landscapes** which were
published, together with his often
vicious **Professional Sketches of
Modern Artists,** after his suicide,
in 1805.
Dayes was predominantly an
architechtural topographer and one of
the greatest exponents of tinted
drawings with grey-blue wash in that
branch of art. By the late 1790's his
technique became richer, more
complex and dependent on the building
up of tones.
 Dayes taught Thomas Girtin from
1789 and in more than one case, Girtin
precisely copied a design by Dayes.
Moreover, both Dayes and Girtin often
based their watercolours on drawings
provided by the antiquarian James
Moore (see pp. 64-65).

57

**The Remains of the Priory Church,
Tynemouth**
1790
watercolour and pencil
502 x 372
signed and dated, lower centre: E. Dayes
1790

exh: **The Romantic Movement**, Tate
 Gallery, 1959 (695)
 Masterpieces, Cartwright Hall
 Bradford, 1977 (48)
ref: **Old Water-colour Society's
 Club**, vol. XX, 1942, p. 4 & pl. VII
 Adrian Bury, **Two Centuries
 of British Water-colour
 Painting**, 1950, p. 53
 Geoffrey Grigson, **Britain
 Observed**, 1975, pl. 45
prov: George Morland Agnew;
 Agnew's, from whom purchased
 by the Laing Art Gallery, 1934
Laing Art Gallery, Tyne and Wear County
Council Museums.

The device of using the archway in
shadow to frame the view is entirely
Picturesque. Engraved by Thomas
Matthews (see cat. no. 6). Illus. below 6
and in colour, p. 54.

(cat. no. 57)

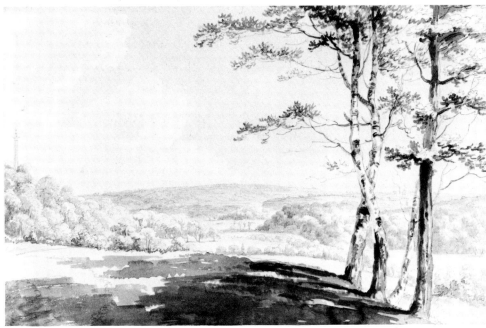
(cat. no. 58)

58
View of Gibside Park, Durham, from Goodshield Haugh
blue, brown and grey wash over chalk
261 x 406
inscribed, upper left: no. 3, and in lower margin: Gibside
ref: English Watercolours and other Drawings from the Helen Barlow Bequest, National Gallery of Scotland, 1979 (16)
prov: Sir Thomas Barlow; Helen Barlow, by whom bequeathed to the National Gallery of Scotland
The Barlow Collection, National Gallery of Scotland.
Illustrated above.

59
Durham Cathedral
pencil and grey-blue wash 181 x 262
inscribed, lower left margin: E. Dayes
prov: W.H.D. Longstaffe, from whom acquired by the Dean and Chapter of Durham
Dean and Chapter of Durham.

60
Raby Castle c. 1791
pencil and grey-blue wash
131 x 258
signed and inscribed lower left: E. Dayes
Lord Darlington/Raby Park
prov: W.H.D. Longstaffe, from whom acquired by the Dean and Chapter of Durham.
Dean and Chapter of Durham.

A pencil and watercolour drawing of this

subject, signed and dated 1790, with the addition of figures and previously in a private collection in New York was sold at Christie's in 1968.

61
Abbey Bridge, near Barnard Castle
1791
watercolour 146 x 223
The Bowes Museum, Barnard Castle, Co. Durham.

62
Lumley Castle 1791, 173 x 109
watercolour and pencil
signed and dated, lower left: E. Dayes
inscribed, reverse: Lumley Castle near Durham the seat of the Earl of Scarborough
prov: N.D. Newall; Newall sale, (Christie's) 13th December, 1979 (37) from which purchased by the present owner
The Earl of Scarbrough.
Engraved by William Angus for **The Itinerant**, 1794 and by C. Pye for Brayley and Britton's **The Beauties of England and Wales**, 1803, vol. v., opp. p.189.

63
Lumley Castle 1791, 134 x 207
pencil and grey-blue wash
signed, lower left: E. Dayes
inscribed, lower right: Lumley
top right:
black tiles ... roof
... castle of a
rich (ye)
like Tynemouth
prov: W.H.D. Longstaffe, from whom acquired by the Dean and Chapter of Durham
Dean and Chapter of Durham.

64
**Durham by Moonlight
(Flambard's bridge)**
1797
pencil and watercolour
107 x 162
signed and dated, lower right: 1797
E. Dayes
ref: Walpole Society, vol. pl. xxviii
 Lightbown, appendix

prov: James Moore; Miss Miller, from
 whom acquired by the Ashmolean
 Museum
The Ashmolean Museum, Oxford.
Maybe identified with a drawing sold by
Dayes to James Moore and for which he
recorded payment in his work diary:
'Recd. of Mr. Moore – for small view
of Durham £1.1.' Ilustrated below.

65
**William Angus, after Edward Dayes
Raby Castle, in the County of Durham,
The Seat of Lord Darlington**
1791
etching and engraving
157 x 203 (plate mark)
Sunderland Art Gallery, Tyne and Wear
County Council Museums.

Published in **The Itinerant**, 1791,
pl. xxv.

66
**William Angus, after Edward Dayes
Lumley Castle in the County of
Durham, the seat of the Earl of
Scarborough.**
1794
etching and engraving
157 x 201 (plate mark)
Sunderland Art Gallery, Tyne and Wear
County Council Museums.

Published in **The Itinerant**, 1794,
pl. xxxvii.

67
**Thomas Matthews, after
Edward Dayes
The Remains of the Priory Church,
Tynemouth**
1813
engraving
246 x 184 (paper size)
Laing Art Gallery, Tyne and Wear
County Council Museums.

Published in Britton's **Architectural
Antiquities of Great Britain**,
Longman & Co., Nov. 1st 1813, and
inscribed 'To SAMUEL WARE ESQ.,
Architect, Author of 'A treatise on the
property of Arches' & c. This plate is
inscribed by J. Britton.'
see cat. no. 57.

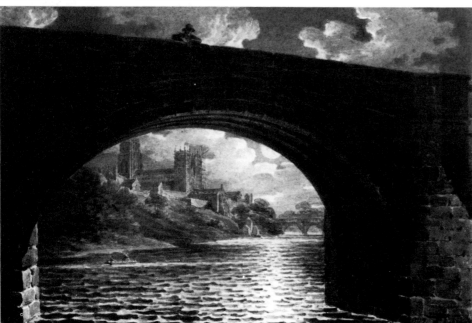

(cat. no. 64)

Edward Edwards (1738-1806)

Edwards was a friend and follower of Paul Sandby. He began his career as a furniture designer, supplying designs to Horace Walpole amongst others, and also opened his own drawing school. Edwards stood for election as Professor of Perspective at the Royal Academy and, failing to get the post, became the scene painter for the Theatre Royal, Newcastle upon Tyne, in 1787.

In 1788, however, he did become Professor of Perspective and later wrote **Anecdotes of Painters**, published in 1808.

Edwards drew the Newcastle Exchange for Brand's **History of Newcastle upon Tyne**, 1789, vol. II, opp. p. 217; the drawing was exhibited at the Royal Acadamy in 1789. The majority of Edwards' other R.A. exhibits are of Castle Eden Dene but he exhibited three views of Brancepeth Castle before his period of residence in the North East. Edwards published a collection of landscape etchings, the large proportion of which was of Northumbrian or Durham subjects.

68
Durham Cathedral
watercolour
130 x 180
prov: Sir Harry Baldwin; Edith Warner; Manning Galleries from whom purchased by the present owner
Private collection.

Possibly used by Edward Dayes as the basis for the drawing later engraved for Britton and Brayley's **Beauties of England and Wales**, vol. XXII, pl.1.

Joseph Farington (1747-1821)

Farington's greatest contribution to the history of British painting are the eight volumes of his Diary for the year's 1793 to 1814, in the Royal Library at Windsor. As an artist he is often considered unsuccessful but his skill as a recorder of detail makes him a talented topographer. He was the pupil and disciple of the landscape painter Richard Wilson who taught him the rudiments of attaining the Claudian ideal of landscape painting.

Farington had private means but found employment by topographical publishers a useful supplement to his income: "topographical draughtsmanship brought out his best and strongest qualities and in using simple pen and colour wash techniques which could be copied by the aquatint engraver he refined and strengthened his art" (exh. cat. Bolton Art Gallery). In 1801, Farington visited Durham during a tour of the North and drew the Cathedral, Elvet Bridge and woods near the city. He records making the study of the Cathedral in his Diary (vol. 1, p. 318), for September 10th; he went on to "Wearmouth", Newcastle, where he stayed at the Turk's Head Hotel, and Alnwick.

69
Elvet Bridge, Durham
1801
pencil and bodycolour
215 x 318
signed and dated, lower left and right: Sept. 10. 1801/Jos. Farington
prov: Palser, by whom given to the Fitzwilliam Museum, 1922
'Fitzwilliam Museum Cambridge.

Henry Gastineau (c. 1791-1876)

Gastineau was of French, probably Huguenot, origin and became an active member of the London art world, exhibiting at the Royal Academy from 1812-1830 and becoming an Associate of the OW-CS in 1823.

Gastineau earned his living mainly as a teacher of drawing but also frequently supplied drawings to Picturesque publications.

When he died he was the oldest surviving member of the OW-CS and had exhibited there for fifty-eight consecutive years. Roget and Hardie say of Gastineau "with him the old school of picturesque topography may be said to have expired."

70
Barnard Castle
pencil and watercolour
500 x 730
prov: Harold Hill, from whom purchased by the Laing Art Gallery, 1930.
Laing Art Gallery, Tyne and Wear County Council Museums.

Thomas Girtin (1775-1802)

Girtin, even more than his exact contemporary Turner, forms the link between the early topographers and the full blown romantic delineation of pure landscape.

Thomas Girtin was born in Southwark, south of the Thames, where his father was a brushmaker.

On 15th May 1789, Girtin was apprenticed to Edward Dayes: their relationship was clearly not a friendly one, judging from Dayes' posthumous character-assasination. It appears that the period in which Dayes taught Girtin was brief but they both continued to work in association with James Moore, the antiquarian, until 1794 or 1795. Girtin and Loshak consider that Girtin must have left Dayes' employ late in 1791 or early 1792.

Both Girtin and Turner learnt much of their art through the patronage of Dr. Thomas Monro and John Henderson who employed young artists to copy the work of both contemporary draughtsmen and the old masters in their houses in Adelphi Terrace. In Monro's case, the principal occupation for both Girtin and Turner was the copying of water-colours and drawings by John Robert Cozens. Farington reported in his diary of 24th October 1798:

"They went to Dr. Monro's house at six and stayed till ten. Girtin drew outlines and Turner washed in the effects. They were chiefly employed in copying the outlines or unfinished drawings of Cozens etc., etc., of which copies they made finished drawings. Dr. Monro allowed Turner 3s.6d each night. Girtin did not say what he had."

In 1796, Girtin made his first trip to the North of England and Scotland and made numerous sketches later worked up to more elaborate water-colours for exhibition and sale. In the Royal Academy exhibition of 1797 he exhibited two views of Jedburgh and two of Lindisfarne Priory. In 1799, before he returned to the North East, he exhibited a view of Warkworth Hermitage at the Academy.

Sketches made on the 1796 tour included two views of Durham Cathedral (Museum of Fine Arts, Boston, and Sir Edmund Bacon collection) which were worked up respectively into the two magnificent water-colours in the Whitworth and the Victoria and Albert, and a view of Newcastle upon Tyne, later worked up and engraved in the **Copper Plate Magazine**, (cat. nos. 86, 82 & 92).

The route of the 1796 tour appears to have been Barnard Castle, Durham, Newcastle, Seaton Sluice, Warkworth, Dunstanburgh, Twizell, Bamburgh, Lindisfarne and Etal.

In 1800, while staying with his patron Edward Lascelles at Harewood House, North Yorkshire, Girtin made an extended tour to Northumberland, the route of which appears to have been Tynemouth, Morpeth, Hexham, Warkworth. Evidence exists in the form of on-the-spot sketches of Tynemouth (Girtin collection) and Morpeth Bridge (cat. no. 88). It appears that Girtin must have also made a sketch from a point further away from the bridge revealing buildings on either side; the result of this sketch are the three versions of **Morpeth Bridge** of which the Laing's version is believed to be the last (cat. no. 89).

Girtin's relationship with the antiquarian James Moore was of considerable importance to Girtin's development as a topographer. James Moore, F.S.A. (1762-1799) was an amateur antiquarian and draughtsman described in his obituary as having "a distinguished rank among the Picturesque topographers of this country." He published two important works: **A list of the Abbies, Priories and other Religious Houses, Castles, etc., in England and Wales, collected from Dugdale etc., etc.,** (1st ed. 1786, revised ed. 1798) and **Monastic Remains and Ancient Castles in England and Wales. Drawn on the spot by James Moore Esq. F.S.A. and executed in aquatinta by G.I. Parkyns, Esq.,** 1792, contributing to many other publications and also sending water-colours to exhibition. In 1785, Moore made his first visit to Scotland and returned via Northumberland.

In August 1792, Moore, accompanied by John Charles Brooke, the herald, and Thomas Girtin made a longer trip to Scotland and a sketchbook in the YCBA (B. 1975.3.691-786) showed that between the 16th and 20th of that month Moore drew Gateshead Monastery, Tynemouth Priory, Bothal Castle, Warkworth Castle, Bamburgh Castle, Lindisfarne Priory and Copeland Castle. Girtin's role was to provide sketches and, subsequently, to work up

water-colours from Moore's own sketches. Edward Dayes (q.v.) also fulfilled this function. Thomas Hearne made a small finished water-colour from a sketch by Moore of the inside of Holy Island Cathedral and an oval vignette engraved from it by B. Howlett is on the title page of Moore's **Lists of the Principal Castles** etc., 1798, (see cat. no. 109).

Moore's **Monastic Remains and Ancient Castles** was among the earliest English topographical coloured aquatinted books. At first, six hand coloured plates were issued but the expense of adding colour by hand made the enterprise too costly and a full set of 72 prints appeared, uncoloured, in 1792. It was not until 1805 that the number of colour plate books published in a single year reached double figures.

Much of James Moore's large collection of drawings by himself, Girtin and others was acquired by the Ashmolean Museum.

71
Bamburgh
c. 1793
watercolour and pencil
169 x 218
signed, lower left: Girtin
ref: Girtin & Loshak, p. 138
 (cat. no. 35)
prov: James Moore; Miller family;
 F.P. Barnard, by whom
 bequeathed to the Ashmolean
 Museum
Ashmolean Museum, Oxford.
Based on a pencil and wash sketch by James Moore made on 19th August 1792, also in the Ashmolean Museum, Oxford, and displayed with the above.

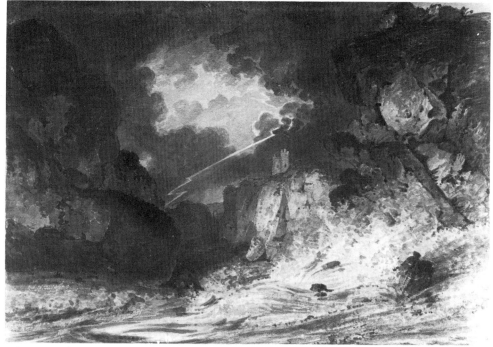

(cat. no. 73)

72
Warkworth Castle
1793-4
watercolour and pencil
360 x 440
ref: Girtin and Loshak, p. 138
 (cat. no. 34 ii)
prov: Augustus Walker, by whom given
 to the Ashmolean Museum, 1921
Ashmolean Museum, Oxford.

Girtin has made an insert which includes a portion of the castle, in the top right corner of the paper. Probably based on a sketch by James Moore who visited Warkworth on 17th August 1792. There is a small drawing in Rochdale Art Gallery. Compare also Turner's water-colour cat. no. 125.

73
Dunstanburgh Castle in a Thunderstorm
late 1794 (?)
watercolour and pencil
165 x 225
ref: Girtin and Loshak, p. 143
 (cat. no. 72)
exh: **Watercolours by Thomas Girtin**
 Whitworth Art Gallery, 1975 (6)
prov: James Moore; Miller family;
 F.P. Barnard, by whom
 bequeathed to Ashmolean
 Museum, 1934
Ashmolean Museum, Oxford.
Girtin and Loshak suggest that this water-colour was based on a design by George Robertson. The landscape is shown in sublime mood. Illus. above.

74

Durham Cathedral
1795
watercolour
260 x 387
signed and dated, lower left: T. Girtin 95
ref: Girtin and Loshak, pp. 148-9,
 (cat. no. 110), repr. fig. 19
prov: Harold Hill, Newcastle upon Tyne,
 from whom purchased, by the
 Laing Art Gallery, 1913
Laing Art Gallery, Tyne and Wear
County Council Museums.

A copy of a water-colour by Edward
Dayes, now in the Yale Center for British
Art (B. 1977.14.4239), which was
probably exhibited at the Royal
Academy in 1795 and was engraved for
Brayley and Britton's **Beauties of
England and Wales**, vol. v,p. 17.
Scaffolding was considered a
Picturesque detail. Both illus. here.

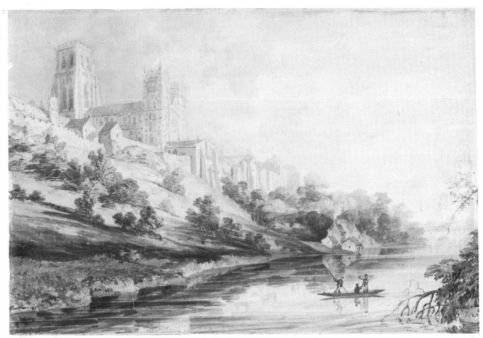

(cat. no. 74)

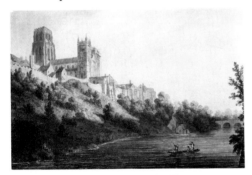

Edward Dayes, Durham Cathedral, (see 74),
Yale Center for British Art (not in exhibition)

75

Etal Castle
1796-7
watercolour
70 x 20
prov: Chambers Hall, by whom given to
 the British Museum, 1855
British Museum.

Aquatinted by J. Hill and published by
Ackermann, May 1st, 1800.

76

Lindisfarne Priory
1796
watercolour, pen and ink and pencil
266 x 209
ref: Girtin and Loshak, p. 156
 (cat. no. 163 i)

prov: T.C. Girtin, from his father the
 artist; Mrs. Barnard; E.P. Barnard,
 by whom presented to the
 Ashmolean Museum, Oxford
Ashmolean Museum, Oxford.

77

Newcastle upon Tyne
1796
watercolour
89 x 163
ref: Girtin and Loshak, p. 156
 (cat. no. 160i)
prov: Sir Charles Robinson;
 Dr. Guillermard, from whom
 acquired by the Fitzwilliam
 Museum

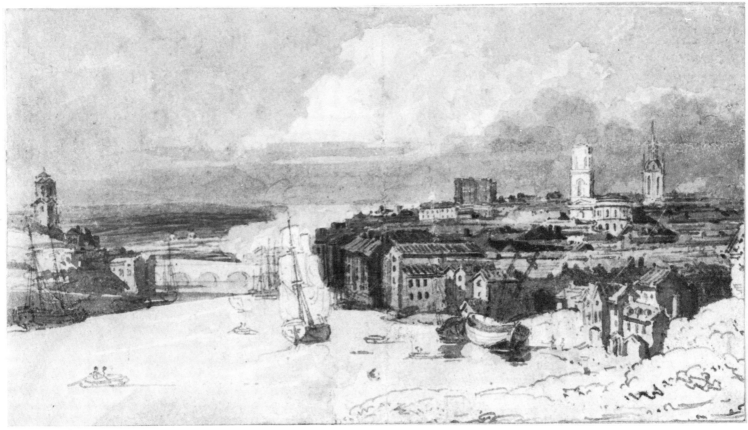

(cat. no. 77)

Fitzwilliam Museum, Cambridge.
Two other versions of this composition
exist, both in water-colour. This is the
on-the-spot sketch. One is in the
National Gallery of Scotland, Helen
Barlow Bequest, the other previously in
the Newall Collection was sold at
Christie's, 13th December, 1979 and is
now in a private collection. The design
was engraved (see cat. no. 92). It is
interesting to note that the spire of All
Saints' Church is shown incomplete but
finished in the engraving. Illus. above.

78
Interior of Lindisfarne Priory
1796-7
watercolour
530 x 393
ref: Girtin and Loshak, p. 159
 (cat. no. 184)
prov: Chambers Hall, by whom given to
 the British Museum, 1855
British Museum.

79
Barnard Castle
1797

watercolour
209 x 339
ref: Girtin and Loshak, p. 160
 (cat. no. 189 i)
exh: **Watercolours by Thomas Girtin**
 Whitworth Art Gallery, 1975 (20)
prov: Chambers Hall, by whom given to
 the British Museum, 1855
British Museum.
Aquatinted by J. Hill and published by
Ackermann, May 1st, 1800. Presumably
based on a sketch made in 1796. See also
cat no. 85.

80

Bamburgh Castle

1797

watercolour

419 x 546

signed and dated, lower left: T. Girtin
1797

ref: Girtin and Loshak, p. 160 (cat.
 no. 192), repr. fig. 34

prov: George Selby of Twizell,
 Northumberland and by descent
 to Sir Geoffrey Church, Bt; his
 sale, Sotheby's 13th March 1980
 (137), at which purchased by the
 present owner

Private collection.

Engraved for **The Copper Plate
Magazine**, pl. cxxxxvi, Sept. 1797.
Family tradition has it that Girtin stayed at
Twizell and was commissioned by Selby
to produce the drawing above.

81

Durham Cathedral

1797-8

watercolour

469 x 412

ref: Girtin and Loshak, p. 166
 (cat. no. 36i)

prov: Chambers Hall, by whom given to
 the British Museum, 1855

British Museum.

Illus. opp.

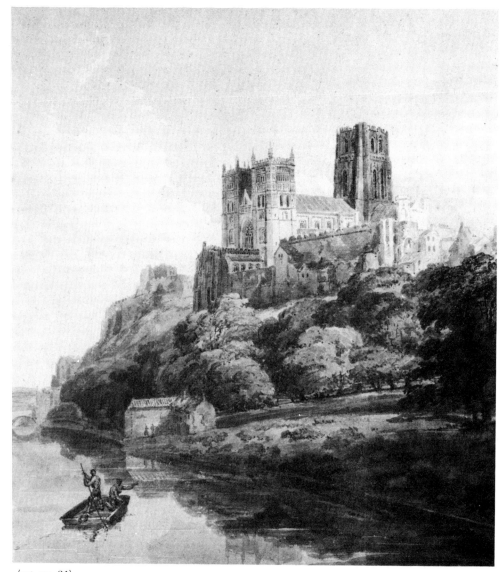

(cat. no. 81)

82
Durham Cathedral
1798
watercolour
394 x 552
signed, lower left: Girtin
ref: Girtin and Loshak, p. 156
 (cat. no. 159 ii)
exh: **Watercolours by Thomas Girtin**
 Whitworth Art Gallery, 1975 (17)
prov: Walker's Galleries, from whom
 purchased by the Victoria and
 Albert Museum, 1928
Victoria and Albert Museum.

Based on a pen and wash sketch made in
1796 and now in the collection of Sir
Edmund Bacon, (Girtin and Loshak,
159 i). Illus. opp.

83
Warkworth Hermitage
1798
watercolour
432 x 562
signed and dated, lower left:Girtin 98
ref: Girtin and Loshak, p. 65, fig. 39
 (cat. no. 238 ii)
exh: R.A. 1799 (396)
 Watercolours by Thomas Girtin
 Whitworth Art Gallery, 1975 (31)
prov: purchased by the Victoria and
 Albert Museum, 1878
Victoria and Albert Museum

Another version of this subject is in the
J. Leslie Wright collection, Birmingham
City Art Gallery, and there is a copy
attributed to James Baynes in the
Whitworth Art Gallery, Manchester.

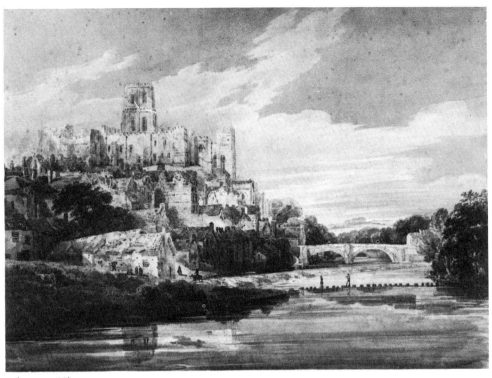

(cat. no. 82)

84
**St. Nicholas' Church,
Newcastle upon Tyne**
1798
watercolour
355 x 304
signed, lower left: Girtin
ref: Girtin and Loshak, pp. 167-8
 (cat. no. 248)
exh: R.A. 1798 (703)
 Watercolours by Thomas Girtin
 Whitworth Art Gallery, 1975 (33)
prov: Sydney Jones, by whom presented
 to the University of Liverpool
The University of Liverpool.

A close copy of this drawing was
engraved by J. Greig as 'From a
drawing by J.L. Bond after a sketch by
T. Girtin's for Britton and Brayley's **The
Beauties of England and Wales**, vol.
xii, part 1, opp. p. 54. Illus. p. 70.

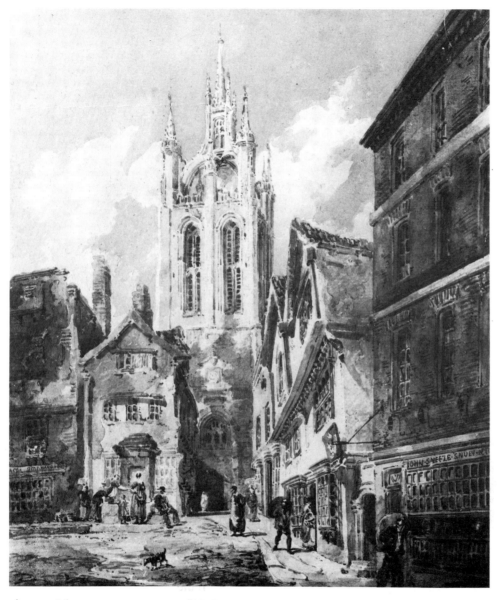

(cat. no. 84)

85
Barnard Castle
1798-9
watercolour
279 x 349
ref: Girtin and Loshak, p. 160
(cat. no. 189 ii)
prov: T.C. Girtin, Mrs. Cooper; 'R.N.'
in 1895; N. Nesham; G. Beatson
Blair; purchased by the Bowes
Museum, 1947
The Bowes Museum, Barnard Castle,
Co. Durham.

Differs in some detail to cat. no. 9;
this version includes a fisherman in
the foreground.

86
Durham Cathedral
1799
watercolour and pencil
416 x 537
signed and dated, lower left: Girtin, 1799
ref: Girtin and Loshak, pp. 61,69,155
(cat. no. 158 iii)
exh: **Watercolours by Thomas Girtin**
Whitworth Art Gallery, 1975 (16)
prov: E.H. Locker; J. Vine; sold to
Colnaghi's 1873; J.E. Taylor 1873-
1892, by whom given to the
Whitworth Art Gallery, 1892
Whitworth Art Gallery, University
of Manchester.

Based on a sketch made in 1796 and now
in the Museum of Fine Arts, Boston
(Girtin and Loshak, cat. no. 159 ii).

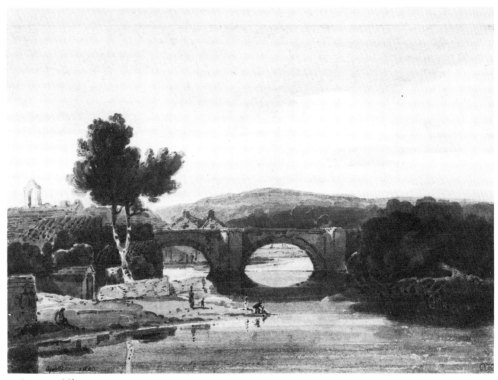

(cat. no. 88)

87
View of the Tyne at Hexham
1800
watercolour
104 x 152
ref: Girtin and Loshak, pp. 181-2
 (cat. no. 347)
prov: Wm. Reed, sold Christie's 1866;
 T.C. Girtin; Mrs. Rogge; Palser;
 Agnew and Norman Lupton, by
 whom bequeathed to Leeds City
 Art Galleries, 1952
Leeds City Art Galleries.

88
Morpeth Bridge
1800
watercolour
228 x 327
signed, and dated, lower left: Girtin 1800
ref: Girtin and Loshak, p. 182
 (cat. no. 349)
prov: Chambers Hall, by whom given to
 the British Museum, 1855
British Museum.

This watercolour shows the bridge from a
nearer viewpoint and with fewer
buildings than the later version.
Illus. above.

89
Morpeth Bridge
1802
watercolour, pencil, pen and ink
314 x 527
ref: Girtin and Loshak, pp. 85-9, 91,
 92, 97 and 108, repr. pl. 99
 (cat. no. 489 iii)
 Hardie, vol. 11, p. 18
prov: W. Wells of Redleaf; C.S. Bale;
 E. Cohen; E. Poulter; F.W. Keen;
 N.D. Newall; Mrs. N.D. Newall;
 her sale, Christie's 13th December
 1979, at which purchased by Tyne
 and Wear County Council
Laing Art Gallery, Tyne and Wear
County Council.

(cat. no. 89)

Hardie, op. cit., wrote 'The **Morpeth**,
stated on the back to be the last
drawing that Girtin made, is all gold
and russet and grey, superb in its
breadth and its lighting; and we may
note the skill of technique by which bare
paper has been left for the two tiny
figures, so perfectly placed as a patching
light on the bridge.'
There are two other versions of this
subject; one in the National Museum of
Wales, Cardiff (Girtin and Loshak, cat.
no. 489 ii) and the other in the
Minneapolis Institute of Art (Girtin and

Loshak, cat. no. 489 i) which was previously in Sir George Agnew's collection and given to Minneapolis by Mr. and Mrs. Atherton Bean in 1977. Illus. below and in colour, p. 51.

90
J. Greig after J.T. Bond and Thomas Girtin
View in Newcastle (with tower of St. Nicholas' Church)
1808
engraving
147 x 102 (image)
prov: Miss Millard, from whom
purchased by the Laing
Art Gallery, 1913
Laing Art Gallery, Tyne and Wear
County Council Museums.

Published in Britton and Brayley's **The Beauties of England and Wales**, vol. xii, pt. 1, p, 54. See also cat. no. 84.

91
John Walker after Thomas Girtin
Bamburgh Castle
1797
engraving
150 x 200 (plate mark)
prov: Edward Brough, by whom given to
the Laing Art Gallery
Laing Art Gallery, Tyne and Wear
County Council Museums.

Published in the **Copper Plate Magazine**, vol. 11, pl. cxxxvi, September 1797. See also cat. no. 80.

92
John Walker after Thomas Girtin
Newcastle upon Tyne
1799
engraving
148 x 200 (plate mark)
Laing Art Gallery, Tyne and Wear
County Council Museums.

First engraved for Walker's own **Copper Plate Magazine**, then retouched by Walker and reissued in **The Itinerant; A select Collection of Interesting and Picturesque Views in Great Britian and Ireland: Engraved from original Paintings and Drawings. By Eminent Artists**, in 1799. See also cat. no. 7.

John Glover (1767-1849)
Glover's first employment was as a writing-master at the age of nineteen in Appleby and he supplemented his income by painting views of gentlemen's seats in the neighbourhood. In 1794 he moved to Lichfield and set up as a drawing master and began to exhibit at the Royal Academy. He moved to London in 1805 and Farington records in that year that "Glover is said to have sold drawings since he came to town to the amount of 700 guineas."
In September of the same year Glover set out for a sketching tour of the North East which lasted from the 20th to 30th of that month. The resulting sketch book (cat. no. 89) includes sketches of Newcastle upon Tyne where he records "I was more interrupted and annoyed while making this Sketch by drunken vulgar Peoples than I ever was at any other place in my life", Durham (the Cathedral from all angles, the Castle and the surrounding countryside), Raby Castle, Barnard Castle, Egglestone Abbey and the junction of the Tees and Greta Rivers.
Durham was the subject of many of the studies ranging from the severely linear to beautiful and atmospheric sketches in ink washes, which illustrate W.H. Pyne's description:
"Who that had not seen this eminent artist at his easel could have supposed the possibility of twisting camel-hair brushes together, spreading them, to the apparent destruction of their utility, yet dipping them in jet black Indian ink, or grey, or such tints as suited his purpose, and by a rapid seemingly adventitious

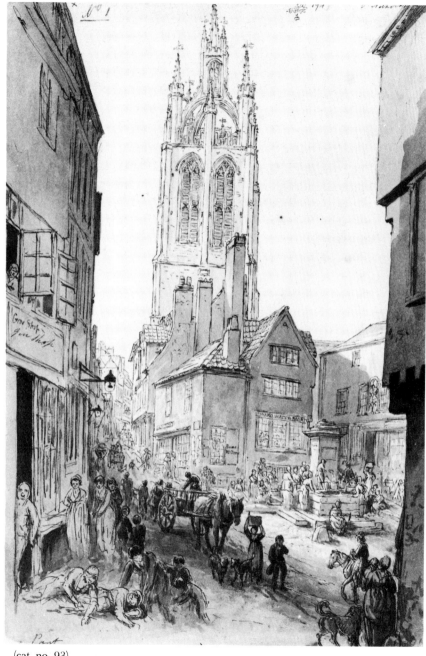

(cat. no. 93)

scrambling over the surface of his design, prepared the light and elegant forms of the birch or willow, the graceful sweepings of the branches of trees of larger growth, and the vast masses of woods and groves sparkling in their various foliage?"

The resulting exhibition watercolours were three views of Durham at the OW-CS the next year and a view of St. Nicholas Church, Newcastle upon Tyne (nos. 149, 233, 242 and 208). North East subjects continue to feature in his exhibition watercolours up till 1819, and suggest that he also visited Prudhoe and Whitfield (the seat of William Ord). John Lambton and the Earl of Durham commissioned paintings from Glover in both oil and water-colour of Durham Cathedral and Lambton Hall.

93
A Sketchbook of Newcastle and Durham
1805
leather bound, pencil, pen and ink and wash sketches
175 x 260 (each page)
insc. inside front cover: J. Glover
 Lichfield
 No. 55 Begun
 20th Sept.1805
 IG
 inside back cover: Finished 30th
 Sept, 1805.
Laing Art Gallery, Tyne and Wear County Council Museums

This sketchbook contains 45 sketches produced in ten days starting in

Newcastle upon Tyne and finishing at Easby Abbey. The majority of drawings, however, concentrate on Durham; the Cathedral, the Castle, the River Wear and surrounding woods. One page shows five views of Durham Cathedral under one of which is written; 'Sold a Picture from this Sketch to Lord Durham for 500 Guineas'. Lord Lambton was an important patron to Glover.
Illus. p. 73.

Samuel Hieronymous Grimm (1733-1794)

Swiss born, Grimm trained under draughtsmen in his native country, worked later in France and eventually, in 1768, settled in England where he produced a vast number of topographical and antiquarian drawings, many for private patrons including Gilbert White, the naturalist of Selbourne, and Dr. Richard Kaye. White has given us an invaluable description of Grimm's technique which is appropriate to the whole school of late C18 topographers:

"Mr. Grimm was with me just 28 days; 24 of which he worked very hard, and showed good specimens of his genius, assiduity and modest behaviour, much to my satisfaction. He finished for me 12 views. He first of all sketches his scapes with a lead pencil; then he pens them all over, as he calles it, with indian ink, rubbing out the superfluous pencil strokes; then he gives a charming shading with a brush dipped in Indian ink; and last he throws a light tinge of water-colours over the whole. The scapes, many of them at least, looked so lovely in their Indian ink shading that it was with difficulty the artist could prevail on me to permit him to tinge them; as I feared the colours might puzzle the engravers: but he assured me to the contrary."

On occasions, Grimm worked entirely in bodycolour in the manner of contemporary Swiss artists: **Bywell Castle** is a glowing example of this technique, (exhibited Royal Acadamy, 1780 (175) now Bodleian Library, Gough Maps, 6f 88, wrongly entitled Bow and Arrow Castle, Isle of Portland). Richard Kaye (1736-1809) was a Prebend of Durham with whom Grimm made a northern tour sketching on his behalf over one hundred antiquities, especially around Durham Cathedral but also in Northumberland and Newcastle. On a sketch there of Rufus Tower, Grimm notes "Aug. 10.1778... N.B. Here I was dogged and on the point of being arrested for a Spy had not Broadie the Landlord turned the constables out."

Gilbert White had objected to Grimm's humour in his drawings and, although there is little enough opportunity for frivolity in topography and antiquarian drawings, a Kaye family outing from Durham to the Farne Islands resulted in two delightful drawings of the family and their servants having their separate picnics. In the former, Grimm has included himself, sketching (cat. nos. 94 & 95).

94
Dinner on Pinnacle Island
1778
pen and wash
150 x 250
exh: **Eat, Drink and be Merry**, Brighton Art Gallery, 1981 (M59)
repr: Clay, pl. 110
G.M. Trevelyan, **An Illustrated Social History of England**, vol. 3, p. 192 and pl. 114
ref: Clay, p. 92
prov: Richard Kaye, by whom given to the British Library
British Library
Illus. p. 75.

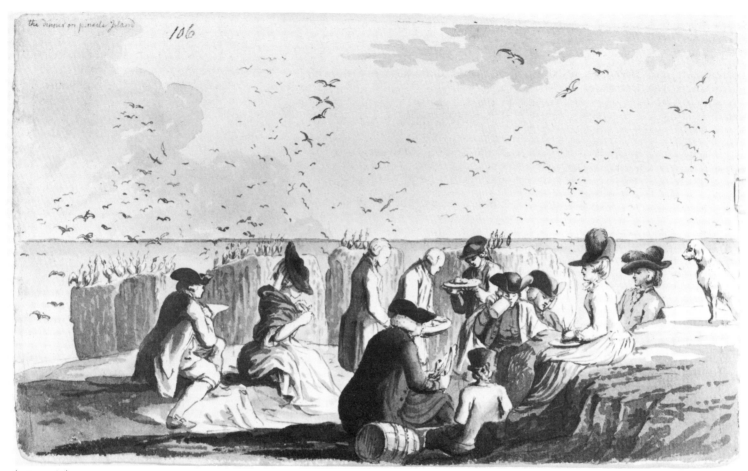

the dinner on pinacle Island 106

(cat. no. 94)

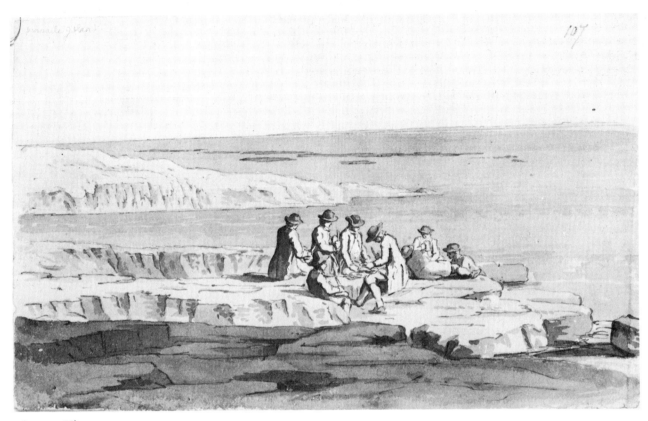

(cat. no. 95)

95
The Servants' Dinner on Pinnacle Island
1778
pen and wash
150 x 250
exh: **Eat, Drink and be Merry**,
 Brighton Art Gallery, 1981 (M60)
repr: G.M. Trevelyan, **An Illustrated Social History of England**, vol. 3,
 p. 192 and pl.115
prov: Richard Kaye, by whom given to
 the British Library
British Library.
Illus. above.

96
Tynemouth Priory
watercolour
257 x 360
inscribed, verso: Tinemouth Priory.
Northumberland/Dugdales Mon. fol. 332
prov: The Squires Gallery, from whom
 purchased by the Laing Art Gallery,
 1938
Laing Art Gallery, Tyne and Wear
County Council Museums.

Although Grimm supplied drawings for
Dugdale's **Monasticon Anglicanum**
this example was not engraved for it.

97
St. Giles Church, Durham
pen and ink and watercolour
178 x 254
prov: Bernard Halliday from whom
 purchased by Sunderland Art
 Gallery, 1938
Sunderland Art Gallery, Tyne and Wear
County Council Museums.

98
Durham Cathedral
pen and ink and watercolour
162 x 248
Sunderland Art Gallery, Tyne and Wear
County Council Museums.

99
S. Sparrow after S.H. Grimm
History preserving the Monuments of Antiquity: The Side View of Lindisfarne at Holy Island Monastery, Northumberland
1784
engraving
226 x 145 (plate mark)
Laing Art Gallery, Tyne and Wear County Council Museums.

The title page of Francis Grose's
Antiquities of England, Wales, Scotland and Ireland, published by S. Hooper, 1785.
Illus. p.26.

Thomas Hearne (1744-1806)
Hearne was born in Wiltshire and, on moving to London, became apprenticed to William Woolett, the engraver, from 1765 to 1771. In that year, Hearne became a draughtsman to Sir Ralph Payne, the governor of the Leewood Islands. After three and half years Hearne returned to England to publish the views made during his stay there. From then on Hearne confined his topography to Britain and in 1777 began work with William Byrne on
The Antiquities of Great Britain,
published in 1807. The dates of publication on the plates, which were engraved by Byrne, S. Middiman and others, range from 1778 to 1806 and Hearne produced fifty two of the drawings. Of Northumberland and Durham, his subjects are: the Hermitage at Warkworth, Lumley Castle, Brancepeth Castle, Tynemouth Monastery, Morpeth Castle, Warkworth Castle and Barnard Castle.
Farington's Dairy for 29th March 1808 records:
"Byrne called today. – He pays Hearne 10 guineas each for the drawings of the "Antiquities of Great Britain", and he becomes the sole proprieter of the 2nd volume. He sells the drawings for 8 guineas.
John Byrne called and told me that he and Hearne, joint proprietors of the first volume of Antiquities of Great Britain had sold the work to Cadell & Davis, and that he had also sold the eight numbers finished of a second volume of Antiquities, in which Hearne had no share. Cadell & Davis gave £16000 for the whole work, meaning to make one volume of it. He did not say how much

of the £1600 was allowed for the first volume." Thomas Monro was a close friend and told Farington in 1795 that he considered "Hearne as superior to everybody in drawing." Hearn disliked Turner's work, considering it lacking in sentiment. Hussey has described Hearne as 'the Picturesque topographer par excellence.'

100
Barnard Castle
1788
watercolour
signed and dated, bottom left: T. Hearne 1788
exh: ? Royal Academy, 1788 (557)
prov: Frank T. Sabin, from whom purchased by the Bowes Museum, 1961
The Bowes Museum, Barnard Castle, Co. Durham.

101
Barnard Castle
watercolour
c. 1788
269 x 395
signed, lower left: Hearne
prov: Squire Gallery, from whom purchased by the Cecil Higgins Art Gallery, 1952
Cecil Higgins Art Gallery, Bedford.
This drawing differs from no. 102 by the exclusion of three small groups of incidental figures.

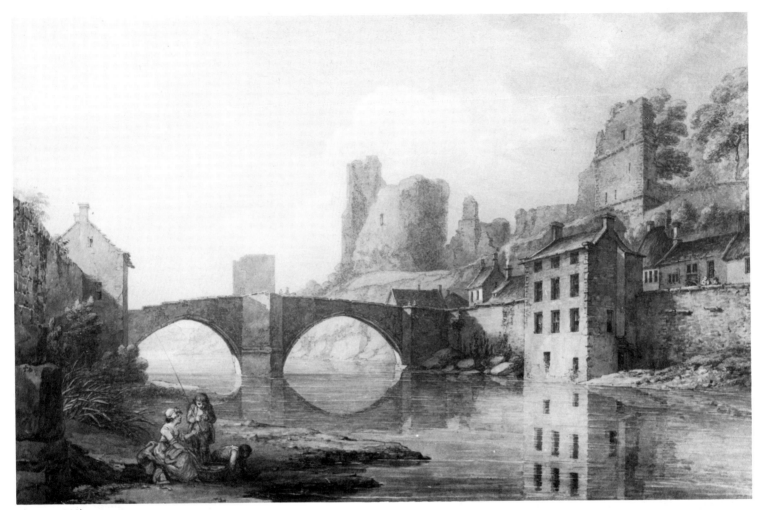

(cat. no. 102)

102
Barnard Castle
pen and ink
200 x 267
signed, bottom left: T. Hearne
prov: G.R. Tuffs, from whom purchased
by the Bowes Museum, 1980
The Bowes Museum, Barnard Castle,
Co. Durham.

Engraved by William Byrne for
Antiquities of Great Britain, vol. 11,
pl. XIII.
Illus. above.

103
Warkworth Hermitage
1779
ink over pencil
191 x 267
British Museum.
Engraved for Byrne's Antiquities of
Great Britain, see cat. no 117.

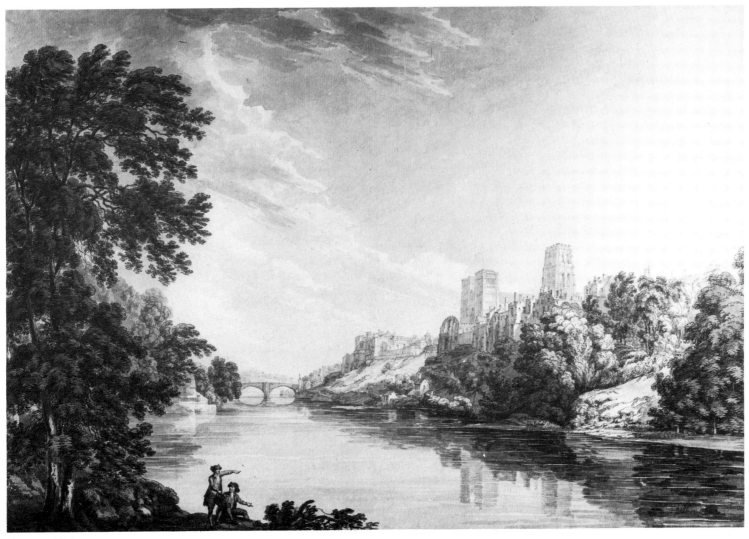

(cat. no. 104)

104
Durham Cathedral
1783
pen and ink and wash
371 x 539
signed and dated, bottom left: T. Hearne
1783

ref: Hardie, vol. 11, p. 177
prov: **British Watercolours in the
Victoria and Albert Museum,**
1980, p. 180
Victoria and Albert Museum

105

Elvet Bridge, Durham
1781
pencil and watercolour
184 x 266
signed and dated, bottom left:
 Hearne 1781
prov: F.P. Barnard, by whom given to the
 Ashmolean Museum
Ashmolean Museum, Oxford.

Etched on a reduced scale by J.C. Varrall,
1st March 1830, for Britton's
**Picturesque Antiquities of English
Cities**, 1830, p. 61. c.f. no. 106 below.

106

Elvet Bridge, Durham
watercolour and indian ink
203 x 254
ref: Hardie, vol. 11, p. 176,
 repr. p1. 180
prov: John Henderson, by whom given
 to the British Museum, 1859
British Museum.

Etched by C.O. Murray, **Portfolio**,
vol. xix, 1888.

c.f. no. 105 above; there is a third version
in the Lloyd collection, Lockinge Hall,
Berkshire. The British Museum and
Ashmolean versions differ in the colour
of the woman's dress: red in the former,
blue in the latter.

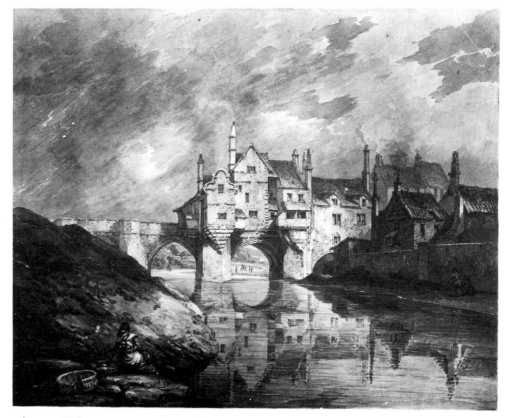

(cat. no. 105)

107

A N.E. View of the City of Durham
c. 1783
watercolour
327 x 454
ref: Leeds Art Calendar, no. 31, 1955,
 p. 18
repr: OW-CS, Club, vol. XXXV, 1960,
 p.16
prov: purchased by Leeds Art
 Collections Fund, 1929
Leeds City Art Galleries.

108

Lumley Castle
c. 1786
pencil and grey wash
142 x 196
prov: N.D. Newall; Mrs. N.D. Newall;
 at her sale, Christie's,
 13th December, 1979 (49),
 at which purchased by the present
 owner
The Earl of Scarbrough.

Engraved by William Byrne and
S. Middiman for Byrne's **Antiquities of
Great Britain**, vol. 1, p1. x (with figures
by Bartolozzi).

109
Lindisfarne Priory
c. 1798
watercolour
182 x 225
signed, lower left: Hearne
ref: Walpole Society, vol. v,. 1917,
 p.87
prov: Moore and Miller collection; given
 anonymously to the Ashmolean
 Museum, 1916
Ashmolean Museum, Oxford.

Based on a sketch by James Moore (see
p. 65) and engraved, as an oval vignette,
by B. Howlett for the title page of Moore's
List of the Principal Castles, etc., 1798.

110
Morpeth Castle
1777
watercolour
184 x 247
signed, lower left: Hearne
prov: Randall Davies, from whom
 purchased by the Laing Art
 Gallery, 1928
Laing Art Gallery, Tyne and Wear
County Council Museums.

Engraved for Byrne's **Antiquities of
Great Britain**, (see below) where it
is dated.

111
**William Byrne after Thomas Hearne
Morpeth Castle**
engraving
218 x 270 (plate mark)
prov: W.B. Reid by whom given to the
 Laing Art Gallery, 1909
Laing Art Gallery, Tyne and Wear
County Council Museums.

Published in Byrne's **Antiquities of
Great Britain**, vol. 2, pl. xlvi.

112
**William Byrne and T. Medland
after Thomas Hearne
Warkworth Castle**
1789
engraving
220 x 275 (plate mark)
Laing Art Gallery, Tyne and Wear
County Council Museums.

Published in Byrne's **Antiquities of
Great Britain**, vol. 2, pl. xlviii.

113
**William Byrne after Thomas Hearne
The Monastery at Tynemouth**
engraving
220 x 274 (plate mark)
Laing Art Gallery, Tyne and Wear
County Council Museums.

Published in Byrne's **Antiquities of
Great Britain**, vol. 1, pl. xlv.

114
**William Byrne and S. Middiman after
Thomas Hearne
Lumley Castle**
1786
proof etching
185 x 284
prov: W.H.D. Longstaffe, from whom
 acquired by the Dean and Chapter
 of Durham
Dean and Chapter of Durham.

Published in Byrne's **Antiquities of
Great Britain**, vol. 1, pl. x with figures
engraved by Bartolozzi (see cat. no. 108).

115
**William Byrne after Thomas Hearne
Barnard Castle**
1799
engraving
185 x 251
Sunderland Art Gallery, Tyne and Wear
County Council Museums.

Published in Byrne's **Antiquities of
Great Britain**, vol. 11, pl. xiii.
See cat. no. 102.

116
**William Byrne after Thomas Hearne,
from a sketch by Edward Edwards
Brancepeth Castle**
1782
engraving
218 x 268 (plate mark)
Sunderland Art Gallery, Tyne and Wear
County Council Museums.

Published in Byrne's **Antiquities of
Great Britain**, vol. 1, pl. xxxv.

117
William Woollett after
**Thomas Hearne
The Hermitage at Warkworth**
1779
engraving
220 x 270 (plate mark)
prov: Edward Brough, by whom given to
 the Laing Art Gallery, 1910
Laing Art Gallery, Tyne and Wear
County Council Museums.

Published in Byrne's **Antiquities of
Great Britain**, vol. 1, pl. ix.

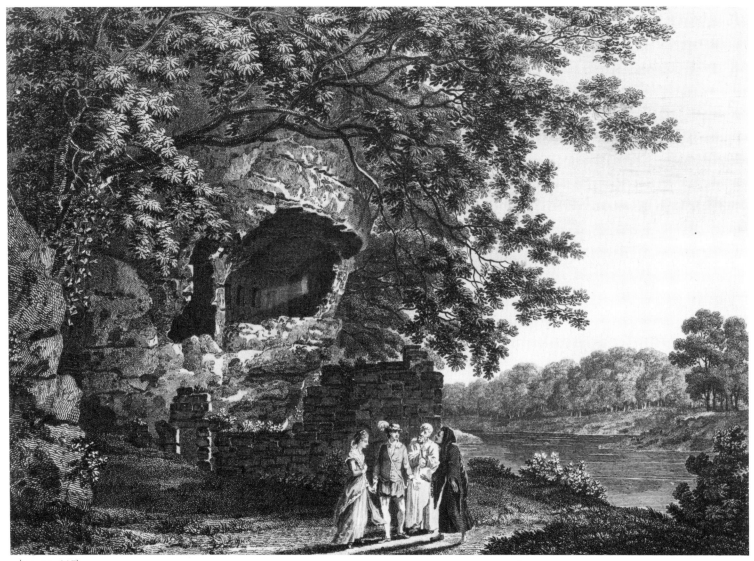

(cat. no. 117)

Illus. p. 82.

Hearne's topographical views are often enlivened by the inclusion of elegant and fashionable strolling figures whose modernity would have offended Gilpin's Picturesque principles:

"No ladies with their parasols – no white-robed misses ambling two by two – no children drawn about on their little coaches, have admittance here" (Instructions for Examining Landscape, pp. 17-18). Here, the figures are characters from Dr. Percy's **Hermit of Warkworth**:

Ah! Seldom had their host, I ween,
 Beheld so sweet a pair:
The youth was tall with manly bloom
 She slender soft and fair.

The youth was clad in forest green,
 with bugle horn so bright:
She in a silken yoke and scarf,
 snatched up in hasty flight.

Thomas Malton II (1748-1804)

Malton's father drew architectural subjects and wrote a **Complete Treatise on Perspective** and gave his son instruction.

Malton junior exhibited architectural views at the Royal Academy between 1773 and 1803, painted scenery for the Covent Garden Theatre, and, like his father became a teacher of perspective. Turner studied under him as a boy and later, as Professor of Perspective at the Royal Academy, acknowledged Malton's skill.

Malton was primarily a draughtsman, drawing buildings with precise, hard outlines, mostly in London but he also accepted commissions for the recording of country seats. Hardie refers to Malton as a "street-artist" as opposed to landscape artist and this woody view of Durham is unusual in his work.

118
Durham Cathedral
watercolour
306 x 436
prov: Davey & Sons, Liverpool, from
 whom purchased by the
 Williamson Art Gallery, 1950
Williamson Art Gallery and Museum,
Birkenhead.

Paul Sandby Munn (1773-1845)

Munn was the son of a carriage decorator and landscape painter whose friend Paul Sandby, the watercolourist and topographer, became namesake and godfather to his son. Sandby gave drawing lessons to his godson, training him sufficiently to enable him to exhibit landscapes at the Royal Academy from 1799. Between 1802 and 1813 Munn supplied drawings to Britton for **The Beauties of England and Wales.**

Munn became a close friend and landlord to John Sell Cotman (q.v.) and together they supplied drawings for the stationer's and printseller's shop run by Munn's two brothers in New Bond Street. To increase the stock of drawings, which were bought by young ladies to copy, Munn and Cotman went off together on sketching tours, visiting Northumberland and Durham in the summer of 1803. His close association with Cotman at a time when the latter was producing some of his most beautiful water-colours does not seem to have diverted Munn from a path of unpretentious topography.

119
St. Hilda's Church, Hartlepool
1810
sepia wash over pencil
307 x 245
signed and dated, lower right: P.S. Munn 1810
prov: Arthur Rogers, from whom
 purchased by the Laing Art
 Gallery, 1935
Laing Art Gallery, Tyne and Wear
County Council Museums.

120
Finchale Priory, Durham
1807
watercolour
209 x 323
signed and dated, lower left: P.S. Munn
1807
prov: given by the Friends of the
 Fitzwilliam Museum, 1939
Fitzwilliam Museum, Cambridge.

121
Finchale Priory, Durham
1810
sepia wash
241 x 355
signed and dated, lower right: P.S. Munn
1810
prov: Joseph Prior, by whom given to the
 Fitzwilliam Museum, 1919
Fitzwilliam Museum, Cambridge.

Francis Place (1647-1728)
Born in County Durham, Place entered
Gray's Inn but rejected the law in
favour of a career in art. His meeting
with Wenceslaus Hollar (1607-77), the
most important of contemporary
etchers, was seminal. They collaborated
on several projects and Hollar
introduced Place to print publishers in
the London art market.
Place began to tour England about
1670 and, within the North-East, visited
Tynemouth, and later Hartlepool,
Dunstanburgh and Bamburgh.
Later, Place became closely involved
with the York Virtuosi and his
commissions therefore expanded from
landscape to illustrations of learned
works. He continued to tour England in
search of topographical views and in
1701 visited Bamburgh again.
Place's connection with Hollar makes
him an important link in the chain that
stretches from the 17th century
topographers of Holland to the
Picturesque tourists of the mid 18th
century. Moreover, he provides us with
some of the earliest views of the area.

122
Bamburgh Castle
1678
pen and wash
133 x 406
inscribed, centre margin: Part of
Bamborough Castle as it appears from
ye South
prov: purchased by the Laing Art Gallery,
1920
Laing Art Gallery, Tyne and Wear
County Council Museums.

Another version is in Leeds City Art
Gallery, dated 1701.
Illus. p.7.

123
Dunstanburgh Castle
1678
pen and ink and indian ink wash
125 x 428
inscribed: centre, The Ruines of
Dunstanburgh Castle in Northumberland
1678
lower r., FP
upper l., and of ye Farne Islands
reverse, bath. Jan 11, 1762. Given me
 that E V. by Wadham
 Wyndham, Esq. at his own
 House; his lady was daughter
 to Mr. Place who made this
 Drawing
exh: **Francis Place 1647-1728**, York
 and Kenwood, 1971 (19)
prov: W & G Smith, 1850, from whom
 purchased by the British Museum
British Museum.

Joseph Mallord William Turner (1775-1851)

Turner was the greatest exponent of water-colour painting and his genius for landscape painting covered the full range of interpretation from pure topography to romantic, personal vision.

His early training was with topographical draughtsmen such as Thomas Malton (q.v.) and Edward Dayes (q.v.) and in the "academy" of Dr. Thomas Monro. Hussey has referred to the latter as a 'temple of the Picturesque' (see p. 64).

From 1797, Turner began an intensive exploration of the British countryside and in the summer of that year travelled to the North East visiting Barnard Castle, Bishop Auckland, Durham, Tynemouth, Warkworth, Dunstanburgh, Bamburgh, Holy Island and Berwick. The evidence for this is to be found in **The North of England** Sketch Book (TB XXXIV), and the **Tweed and Lakes** Sketch Book (TB XXV) inside the front cover of which is inscribed "Ambleside Mill – Mr. Lambert Durham Castle Mr. Hoppner". On 19th June, 1801 Farington records that Turner was leaving the next day for a three month tour of Scotland with a "Mr. Smith of Gower St." He left for Durham, Newcastle, Morpeth, Alnwick and Berwick; Farington promised to send him "directions to particular picturesque places."

On 21st November, 1817, Turner wrote to James Holworthy, "Lord Strathmore called at Raby and took me away to the north". Turner had just returned to England from his first tour of the Rhine and appears to have stayed with his patron Walter Fawkes at Farnley in Yorkshire, going next to Durham to take notes for Surtees' **History of Durham**. A number of sketches of the city appear in the **Durham, North Shore** Sketch Book (TB CLVII). In the same sketch book there are sketches of Prudhoe Castle, one of which appears to have been the basis for the magnificent watercolour of Prudhoe Castle, circa 1826 (BM 1958-7-12-428), illus. p.39. At the same time, Turner made several studies of Raby Castle (TBCLVI) and both sketchbooks show that he went to Gibside, Newcastle, Hylton Castle, Bishop Auckland and Barnard Castle.

Rawlinson quotes the Rev. W. Kingsley's statement that Turner made the drawing "from memory, he having been struck with the view as he was being driven past, whilst on a visit to the Swinburne family. He wanted to stop the carriage and make a sketch, but time would not permit." The watercolour was later engraved (cat. no. 135). it is a perfect example of later romantic licence in altering and adapting a landscape for pictorial effect: The Tyne Valley is seen in poetic and Italianate mood.

Sir John Swinburne (1762-1860) and his son Edward were both patrons, and the latter a pupil, of Turner and one of them appears to have commissioned two watercolours of 1820, **Biebrich Palace** (BM 1958-7-12-420) and **Marksburg** (BM 1958-7-12-422) selected from Walter Fawkes' set of Rhine views. Both water-colours were exhibited at the Northern Academy of Arts, Newcastle upon Tyne, 1828 (nos. 74 and 71, respectively).

Turner painted several major oil paintings of North East subjects. At the Royal Academy in 1835 he exhibited **Keelmen Heaving Coals by Night** (National Gallery of Art, Washington, Widener Collection) illus. p. 86. It appears to have been painted as a contrasting pair to a painting of Venice. In 1838, William Pearson wrote "The river is not navigable for larger vessels beyond ye bridge at Newcastle but ye "Keels" run up some miles higher. These boats are black – in which respect they resemble ye Venetian gondolas: but here I should conceive ye similarity end, they are, I was going to say, black and dirty enough but still they have rather a pitcuresque appearance." Turner had previously painted the industrial Tyne in two water-colours of **Shields, on the River Tyne** and **Newcastle-on-Tyne** (cat. nos. 128 & 129).

"The Raby" Sketch Book of 1817 contains preparatory studies for the painting **Raby Castle, the Seat of the Earl of Darlington**, exhibited at the Royal Academy in 1818 (198; now Walters Art Gallery, Baltimore): "the last and grandest of Turner's topographical house-portraits in the eighteenth-century tradition " (illus. p. 38) Between 1807 and 1819, Turner issued a series of mezzotints in fourteen parts entitled the "Liber Studiorum", which, through its title and its technique, imitates Claude's "Liber Veritatis", published by Boydell in the 1770's. Each of the fourteen parts appears to

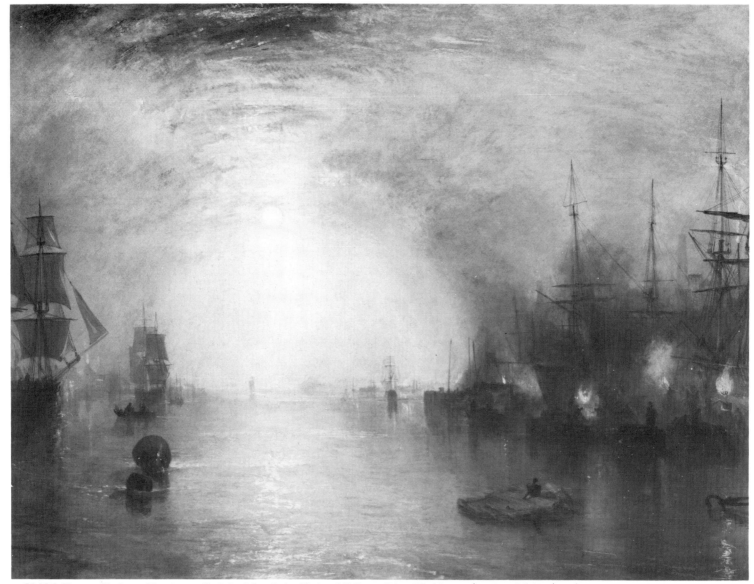

J.M.W. Turner, Keelmen Heaving in Coals by Moonlight, National Gallery of Art, Washington (not in exhibition)

have been intended to include an example of each of the five branches of landscape which Turner called "Historical, Mountainous, Pastoral, Marine and Architectural". Turner also frequently uses "E.P." (which probably stood for "Epic" or "Elegant Pastoral") as an additional category.

Turner's first commission as a topographer was for the **Copper Plate Magazine** in 1793 and, it is said, was paid two guineas for each plate with a small allowance for travelling expenses. A stipulation was that every drawing should be made on the spot. Two descriptions of Turner as a Picturesque tourist are worth including:

"(Between 1793 and 1798) he travelled mostly on foot, with his drawing material and his scanty wardrobe slung in a bundle over his shoulder, and usually carrying his fishing rod" (Rawlinson).

Alaric Watts, a contemporary, provides us with this further description:

"He walked twenty to twenty five miles a day, sketching rapidly on his way all striking pieces of composition and marking effects with a power that daguerrotyped them in his mind. There were few moving phenomena in clouds and shadows that he did not indelibly fix in his memory, though he might not call them into requisition until years afterwards" (**Liber Fluviorum**, 1857, preface).

Turner's "central and most ambitious work in black and white" was **Picturesque Views in England and Wales**, begun in 1826. The scheme was originally conceived by Charles Heath and was to include 120 copper engravings of towns, landscapes and ancient buildings. The final version included 96 plates, and was issued in numbers from 1827 to 1838.

J.M.W. Turner, Raby Castle, the seat of the Earl of Darlington, Walkers Art Gallery, Baltimore
(not in exhibition)

124

Durham Cathedral from the river
c. 1799
watercolour and pencil
305 x 407
signed, lower right: W. Turner
rcf: Wilton, 1979 (249)
prov: John Hoppner, R.A., for whom
 drawn; from whom acquired by
 the Royal Academy
Royal Academy of Arts.

Farington's Diary for 24th October 1798
notes that Turner told him that
Hoppner had chosen this subject to be
executed as a present.

125

**Warkworth Castle, Northumberland-
Thunderstorm approaching at sunset**
c. 1799
watercolour
521 x 749
ref: Wilton,1979 (256); Wilton,1980, p. 68
exh: R.A. 1799 (434)
prov: Ellison, by whom given to the
 Victoria and Albert Museum
Victoria and Albert Museum.
Illus. above.
Based on a drawing on p. 40 of the **North
of England** Sketch Book (TBXXXIV);
the design was used in **Rivers of
England**, 1826 (Rawlinson 762). The
corresponding water-colour (Wilton 742)
is missing and it is possible that
the plate was engraved direct from this
large water-colour. Accompanied in the
catalogue to the 1799 Royal Academy
exhibition by the following quotation from
Thompson's **The Seasons**:

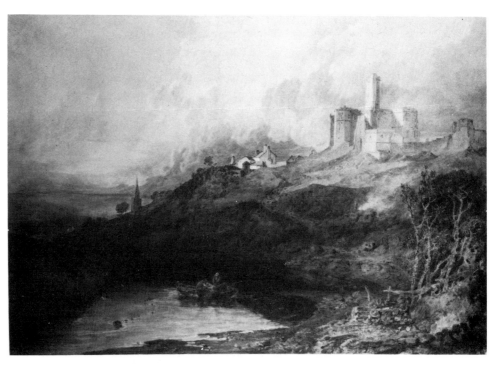

(cat. no. 125)

"Behold slow setting o'er the lurid grove,
Unusual darkness broods; and growing,
gains the full possession of the sky; and on
yon baleful cloud

A redd'ning gloom, a magazine of fire,
Ferment."

An example of Turner using elemental
forces and their threat to man as the
backdrop of a Picturesque scene: the
landscape sublime. The quotation has
been amended by Turner.

126

Durham Cathedral: Interior
c. 1800
watercolour
762 x 584
ref: Wilton 1979 (276)
exh: **Turner and the Sublime**,
 British Museum, 1981 (ex. cat.)
British Museum (TB XXXVI-G)

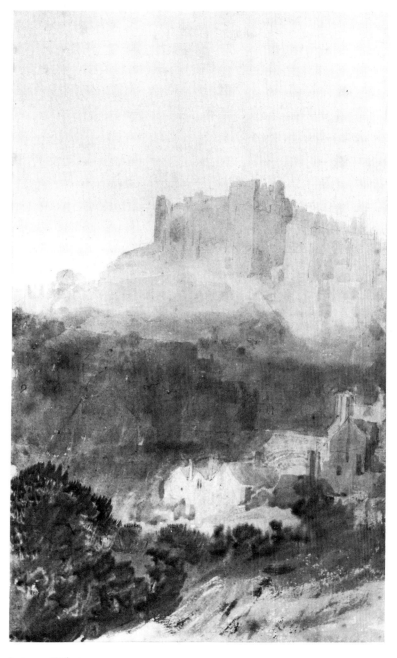

(cat. no. 127)

127
Durham Castle
1801
watercolour and pencil
405 x 250
ref:　Wilton 1979 (315)
prov: Thomas Griffith, A.J. Finberg;
　　　Miss Lupton; Agnes and Norman
　　　Lupton bequest, 1952.
Leeds City Art Galleries.

Illus. opp.

128
Shields on the Tyne
1823
watercolour
154 x 216
signed and dated, bottom left:
JMWT 1823
ref:　Wilton, 1979 (732); Rawlinson
　　　(752)
British Museum (TB CCVIII-V)
Engraved by Charles Turner, for **The
Rivers of England**, June 1823.

129
Newcastle upon Tyne
c. 1823
pencil and watercolour
152 x 215
ref:　Wilton 1979 (733); Rawlinson
　　　(753)
exh:　British Museum, 1975 (85)
British Museum (TB CC VIII-K).
Engraved by Thomas Lupton for **The
Rivers of England**, June 1823
(see no. 133 below). A pencil study for this
view is f.2 of the **Scotch Antiquities**
sketchbook, 1818 (TB CLXVII. 2),
omitting the detail of the foreground. The
viewpoint and device of staffage sitting on
the bank are an interesting comparison to
Girtin's Newcastle upon Tyne. (cat. no.77)

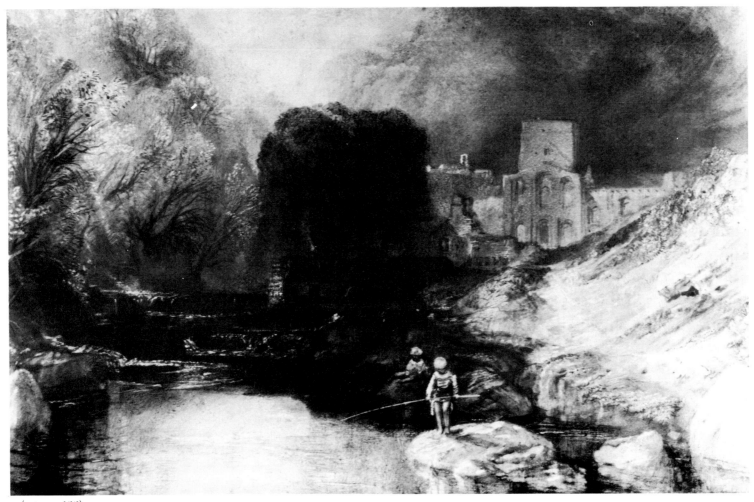

(cat. no. 132)

130

Tynemouth Priory, Northumberland

c. 1818
watercolour
159 x 241
ref: Wilton 1979 (545)
prov: Mrs. Sara Austen, sale Christie's
 10th April 1889 (199, as 'off Holy
 Island'), bt. Vokins; J. Vavasseur,
 sale Christie's 23rd April 1910 (21,
 as 'off Holy Island'),
 bt. Vicars; Mrs. G.H. Bailey;
 J. Yates, by whom given to
 Blackburn before 1962
Blackburn Art Gallery.

Illus. below.

The water-colour study for his view is TB
XXX-111-T; a later study with colour is
in **North of England** Sketch Book,
TB XXXIV-33 and is the basis for
**Picturesque Views in England and
Wales** engraving.

131

Holy Island, Northumberland

c. 1829
watercolour, bodycolour, scraping out
and pen and ink
292 x 432
ref: Wilton, 1979 (819); Rawlinson
 (243)
prov: G. Loundes (1833); B.G. Windus;
 D.R. Davies; A.W. Nicholson;
 Lady Wakefield, by whom given to
 the Victoria and Albert Museum,
 1943

Victoria and Albert Museum.

Engraved by W. Tombleson, 1830, for
**Picturesque Views of England
and Wales.**

132

Brinkburn Priory, Northumberland

c. 1830
watercolour
292 x 463
ref: Wilton, 1979 (843)
prov: B.G. Windus; Jos. Gillott sale,
 Christie's, 4th May 1872 (509).,
 W. Cox; sale Thomas & Bros.,
 Birmingham, 8th April 1892 (89);
 Lawrence W. Hodson sale,
 Christie's, 25th June 1966 (128),
 Agnew; Sir Jos. Beecham;
 N.J. Nettlefold by whom
 bequeathed to the Graves Art
 Gallery, Sheffield, 1958.
Sheffield City Art Galleries.
Ilus. p. 90.
Based on a pencil study from Smaller

Fonthill sketchbook of c. 1801 now in the
Fogg Art Museum, Harvard (1907.12).

133

**Thomas Lupton after J.M.W. Turner
Newcastle upon Tyne**

1823
mezzotint engraving
195 x 250 (plate mark)
lit: Rawlinson (753)
prov: Matthew Mackay; purchased by
 the Laing Art Gallery, 1919
Laing Art Gallery, Tyne and Wear
County Council Museums.
Illus. p. 92.
Published in **The Rivers of England**,
1823-7, p.2; for details of the sketch and
watercolour see no. 129, above.

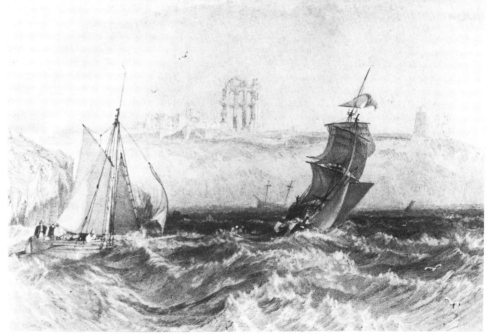

(cat. no. 130)

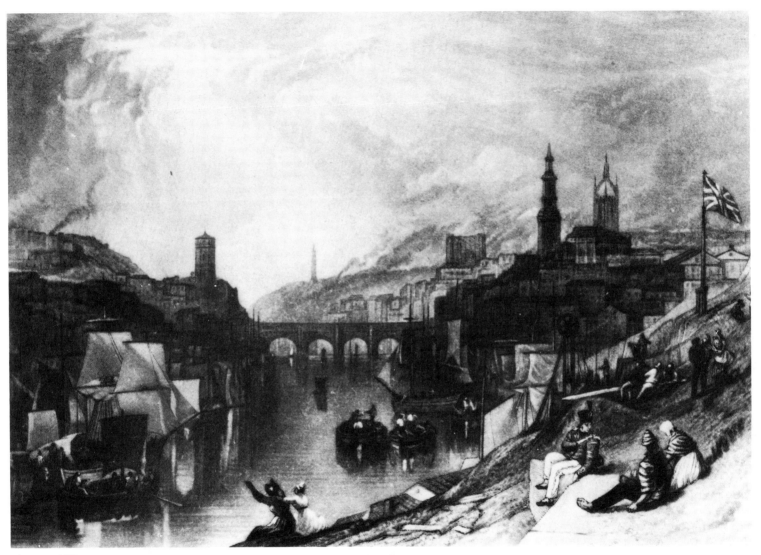

(cat. no. 133)

134

Charles Turner after J.M.W. Turner
Morpeth, Northumberland
1807
etching and aquatint
205 x 287 (plate mark)
lit: Rawlinson (21)
Laing Art Gallery, Tyne and Wear
County Council Museums.

Morpeth Bridge was not a subject
frequently chosen by artists; it was a
favourite motif of Girtin and, according
to a manuscript note in the B.M.'s own
copy of Binyon's catalogue, John Varley
also painted it.

135

Edward Goodall after J.M.W. Turner
Prudhoe Castle
1828
engraving
244 x 305 (plate mark)
ref: Rawlinson (222)
prov: Edward Brough, by whom given to
 the Laing Art Gallery, 1910
Laing Art Gallery, Tyne and Wear
County Council Museums.

Published in **Picturesque Views of**
England and Wales, 1827-1838. The
water-colour from which the engraving
was made is in the British Museum
(1958-7-12-428); a drawing of the view is
in the **Durham, North Shore**
Sketchbook (TB C LVII, 77v-78) 'A
Prudhoe Castle' sold by a 'Collector from
the North' at Christie's 8th May 1855
(62), bt. Wallis.

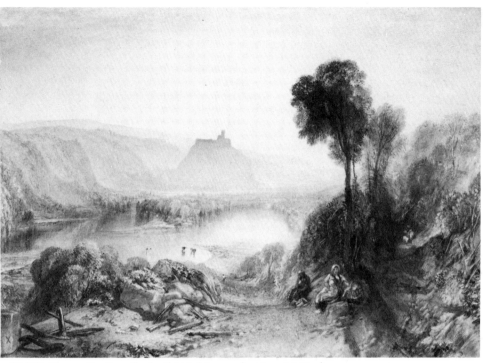

J.M.W. Turner, Prudhoe Castle, British Museum (not in exhibition)

136

J.T. Willmore after J.M.W. Turner
Alnwick Castle 1820
engraving
254 x 318 (plate mark)
ref: Rawlinson (242)
prov: Edward Brough, by whom given to
 the Laing Art Gallery, 1910
Laing Art Gallery, Tyne and Wear
County Council Museums.

Published in **Picturesque Views in**
England and Wales, 1827-1838. The
water-colour from which the engraving
was made is in the Art Gallery of
South Australia, Adelaide which in turn
is based on a drawing in the **North of**
England Sketchbook, 1797
(TB XXXIV-44).

137

S. Rawle after J.M.W. Turner
Gibside, Co. Durham, the seat of the
Earl of Strathmore
c. 1820
engraving
191 x 280 (image)
ref: Rawlinson (142)
prov: Harold Finlinson, from whom
 purchased by Sunderland Art
 Gallery, 1954
Sunderland Art Gallery, Tyne and Wear
County Council Museums.

Published in Robert Surtees' **History of**
Durham, vol. 2, p.254. The original
water-colour is now in a private collection
and illustrated on page 94, with the
water-colour of Hylton Castle.

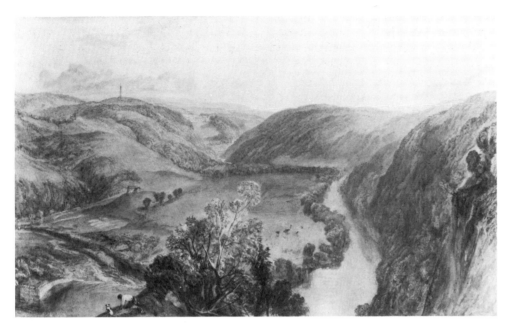

J.M.W. Turner, Gibside (not in exhibition)

138
S. Rawle after J.M.W. Turner
Raby Castle, Co. Durham, the seat of
the Earl of Darlington.
c. 1820
engraving
191 x 284 (image)
ref: Rawlinson (143)
prov: Grant, from whom purchased by
 Sunderland Art Gallery, 1940
Sunderland Art Gallery, Tyne and Wear
County Council Museums.

Published in Robert Surtees' **History of**
Durham, vol. 4 appendix.
A proof engraving.

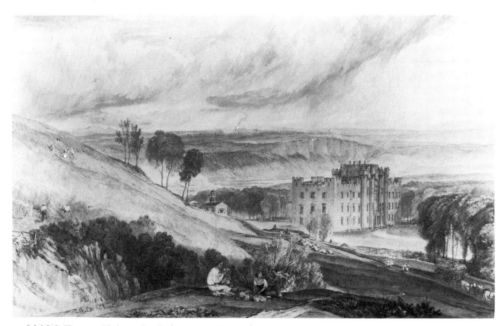

J.M.W. Turner, Hylton Castle (not in exhibition)

139
Robert Wallis after J.M.W. Turner
Barnard Castle
1827
engraving
166 x 229 (image)
ref: Rawlinson (217)
prov: Harold Finlinson, from whom
 purchased by Sunderland Art
 Gallery, 1954
Sunderland Art Gallery, Tyne and Wear
County Council Museums.

Published in **Picturesque Views of**
England and Wales, 1827-1838. A
reduced version of the design was
engraved by J.T. Willmore for
The Talisman, 1831 (Rawlinson 341).
The water-colour, c. 1825, is in the Yale
Center for British Art.

John Varley (1778-1842)

Born in Hackney, London, Varley was an influential member of the school of English water-colourists, both as a painter of landscapes in the Claudian convention and as a teacher of professional and amateur artists. Varley was one of the sixteen founder members of the Old Water-Colour Society in 1804 and was a member of the Sketching Club, founded by Girtin and continued by Cotman. Varley was a prolific and various artist and at his best produced some splendid landscapes.

His early work shows the influence of Girtin, particularly in its grey-blue tonality. His later work, from about 1812, exemplifies his own dogma, "Nature wants cooking", and "Every picture should have a **look-there**", derived from the example of Claude & Poussin through Turner. Often, his landscapes were imaginary, conceived of and exhibited as "compositions." We know something of his working method: for outdoor work, Varley recommended a thick, rough paper, like cartridge, adding "if the thin wove papers be used, they should be mounted; that is pasted on two thicknesses of cartridge paper, previously pasted together and strained on a board in the manner of pasteboard."

Through his teaching, Varley was able to exercise a great influence on the viewing of the landscape in Picturesque terms. At one time he earned a huge amount for those days, £3,000, but was also continuously in financial difficulties, often even in the debtors' prison and dependent on the generosity of his friends. Charles Ranken, wrote to Sir John Swinburne from Gray's Inn, 30th May 1823: "Mr. John Varley's business I am sorry to say does not appear more promising than the other – before his Bankruptcy he repeatedly engaged to collect from the different parties who hold them and to deposit with me the different Copper Plates and Copyrights of several Publications as security for your loan but I never could obtain them and he either so egregiously deceived himself or misrepresented to me the state of his affairs that all your good intentions in his favor were certainly frustrated altho his still continues to attribute to your assistance the final arrangements as he calls it of his affairs which was completed by his Bankruptcy." (Swinburne papers, Northumberland County Record Office).

He was patronised by the nobility, usually for the teaching of their daughters and many country houses have water-colour compositions produced by ancestors in the manner of Varley.

In Northumberland, his patrons included Sir John Edward Swinburne of Capheaton, the Countess of Tankerville and William Ord of Whitfield. The Countess of Tankerville appears to have employed Varley both in London where he drew the Thames from the garden of her Villa at Walton and at her home in Chillingham where Varley taught her daughter Mary, who was later to become the wife of Charles Monck of Belsay, Northumberland.

William Ord (1781-1855) bought many works by Varley including the romantic Girtinesque view of Newcastle upon Tyne of 1808. The Victoria and Albert Museum have a sketchbook (E3242-1931) of that year which has studies of Bamburgh, Beadnall, Dunstanburgh, Warkworth Castle and the Warkworth Bridge tower.

140
Newcastle upon Tyne
1808
watercolour and pencil
signed and dated, bottom right: J. Varley/
1808
prov: William Ord and thence
by descent
Private collection.

Illus. in colour, p. 52.

141
Lilburn Tower, Dunstanburgh Castle
1810
watercolour and pencil
330 x 265
Signed and dated, bottom right: J. Varley
1810
prov: Lord Clywd; Appleby Bros.,
Mrs. Sheila Pettit; Owen Humble;
Anderson and Garland, Newcastle
upon Tyne, sale 25th March 1981,
from which purchased by Tyne and
Wear County Council Museums
Laing Art Gallery, Tyne and Wear
County Council Museums.

Illus. opp.

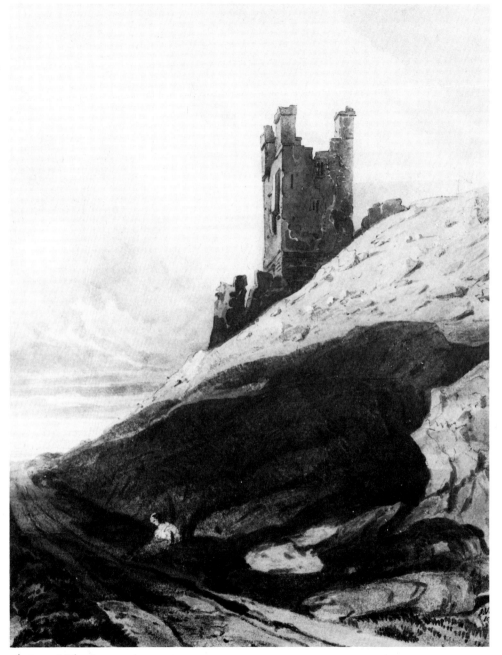

(cat. no. 141)

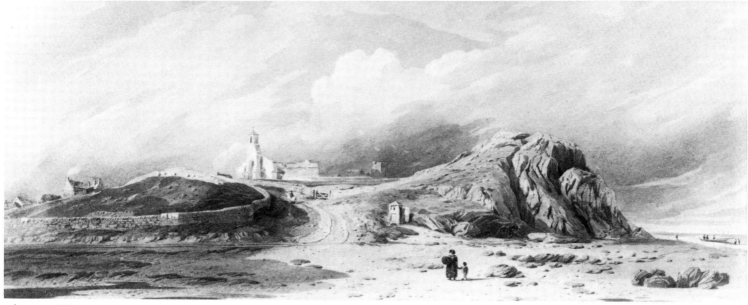

(cat. no. 142)

142
Holy Island
1808
watercolour
325 x 810
signed and dated, lower right: J. Varley
1808
ref: OW-CS Club, vol. xx, 1942, p.4
prov: purchased by the Trustees of the
 Walker Mechanics' Institute under
 the terms of the Wigham
 Richardson Bequest and given to
 the Laing Art Gallery
Laing Art Gallery, Tyne and Wear
County Council Museums.
Illus. above.

143
Holy Island
1810
watercolour
258 x 308
signed and dated, lower right: J. Varley.
1810
ref: OW-CS Club, vol. XX, 1942, p.4
 & pl. 1X
prov: Alfred W. Rich, by whom
 bequeathed per Mrs. C.P.
 Halliday, to the Laing Art Gallery,
 1935
Laing Art Gallery, Tyne and Wear
County Council Museums.
Alfred Rich wrote of this work 'I have in
my possession a picture of Holy Island
Castle by John Varley, signed and dated
1810. An apparent replica of this
drawing, evidently done in the studio,
signed and dated 1811, is in one of the
public museums (Victoria and Albert). If
these two drawings are compared it is
very evident that the earlier one, which
was no doubt painted out of doors, is the
great work, and the carefully laboured
one done at a later time falls far below
it in merit.' (quoted in OW-CS Club,
vol. XX, 1942, p.4).

144
Dunstanburgh Castle
watercolour
285 x 430
prov: Harold Hill, from whom
 purchased by the Trustees of the
 Walker Mechanics' Institute under
 the terms of the Wigham
 Richardson bequest in 1940 and
 given to the Laing Art Gallery
Laing Art Gallery, Tyne and Wear
County Council Museums.

145
The Farne Islands
watercolour and pencil
260 x 440
inscribed, lower left: I Varley
prov: private collection, Newcastle upon
 Tyne; their sale, from which
 purchased by present owner
Private collection.

An unusual choice of subject matter but
treated in a typical Varley manner,
emphasising the large expanse of sky and
water of a coastline which was very
familiar to him.

146
Durham Cathedral
watercolour
146 x 245 (sight)
prov: Agnew's, from whom purchased by
 the present owner
Private collection.

147
Chillingham Castle
watercolour and pencil
141 x 199
prov: Lady Mary Monck, and then
 by descent
Private collection.

148
Walton Bridge
pencil and ink
183 x 250
Signed, lower right: J. Varley
prov: Lady Mary Monck, and then
 by descent
Private collection.

149
Sketchbook
containing mounted sketches and notes
127 x 278 (each page)
prov: Lady Mary Bennett; by descent;
 given to the Laing Art Gallery,
 1949
Laing Art Gallery, Tyne and Wear
County Council Museums.

This sketchbook is believed to have
been compiled by Lady Mary Bennett,
later Lady Monck, who was a pupil of
Varley. It contains sketches by Varley
and instructions written in his hand, e.g.
'A wild straggling tree is more in
character with a mountain scene than
one thick of foliage'. Views of
Chillingham Castle are included.

Appendix

A curious landmark in the history of topography was the designing of a vast dinner service for the Empress Catherine of Russia by Josiah Wedgwood. This nine hundred and fifty-two piece set of cream-coloured earthenware (Queen's ware) was decorated with hand-painted monochrome views of "ruins, the most remarkable buildings, parks, gardens and natural curiosities" but omitted modern buildings "considering them unpicturesque".

Wedgwood originally planned to have water-colours made for all one thousand two hundred and forty-four views but also had to have recourse to published views. He wrote to his partner Thomas Bentley on 30th July 1773:

"There is another source for us besides the published views and the real parks and gardens. I mean the paintings in most noblemen's and gentlemen's houses of real Views . . . but I hope that prints may be picked up to go a great way or we shall be sadly off as they (the pieces) are to be numbered and named".

The places selected indicate the areas considered to be of interest and importance at that date. A list of Northumbrian and Durham sites follows.

The service was put on display at Wedgwood's premises in Greek St., Soho, in the summer of 1774 before exportation, and was an immediate social success.

For further details see Dr. G. C. Williamson, **The Imperial Russian Dinner Service**, 1909.

52. View of the Monastery at Tinmouth, Northumberland.
53. Bothal Castle, Northumberland, the property of the Earl of Oxford.
54. Dunstanburgh Castle, Northumberland, the property of the Earl of Tankerville.
55. View of the Castle and Monastery on Holy Island, Northumberland.
128. View of Tinmouth Castle, Northumberland.
210. View of a part of Tinmouth Castle and the Mouth of the Tine.
267. Dunstanburgh Castle, Northumberland, the property of the Earl of Tankerville.
268. Warkworth Castle, Northumberland, the property of the Duke of Northumberland.
300. View of Tinmouth Castle, Northumberland.

378. View of the Monastery at Jarrow, near Durham.
379. Morpeth Castle, Northumberland.
389. View of a part of Prudhoe Castle, Northumberland, the property of the Duke of Northumberland.
393. View of a part of Prudhow Castle, Northumberland, the property of the Duke of Northumberland.
398. Norham Castle, Northumberland.
431. View of Bothal Castle, Northumberland, the property of the Earl of Oxford.
462. Alnwick Castle, Northumberland.
466. View of Chillingham Castle, Northumberland, the country seat of the Earl of Tankerville.
471. View of Lumby Castle, Durham, the country seat of Lord Scarborough.

486. View of Widdrington Castle, Northumberland.
576. View of part of Dunstanburgh Castle, Northumberland.
587. View of part of a Castle and Monastery of Holy Island, Northumberland.
644. View of Alnwick Castle, Northumberland, one of the Duke of Northumberland's country seats.
671. View of the Hermitage near Warkworth, Northumberland.
694. View of Tinmouth Castle and Priory.
699. Distant view of Alnwick Castle, Northumberland.
760. View of Brinkburn Priory, Northumberland.
807. View of a part of Biwell Bay, Northumberland.

828. View of the Chapel of Our Lady,
 near Bothall, Northumberland.
887. View of Bywell Bay,
 Northumberland.
1001. View through a cell of Warkworth
 Hermitage, Northumberland.
1002. View of a Druids' Cabin at the foot
 of Mount Cormelin,
 Northumberland.
1004. Part of the City of Durham.
1139. View of Warkworth Castle,
 Northamptonshire.
1273. The Entrance of Tinemouth Castle,
 Northumberland.
1274. Bamburgh Castle,
 Northumberland.

BIBLIOGRAPHY AND REFERENCES

Books are published in London unless otherwise specified.

The Picturesque

Barbier	Carl Paul Barbier, William Gilpin: his drawing, teaching and theory of the Picturesque, Oxford, 1963.
Bicknell	Peter Bicknell, Beauty, Horror and Immensity, Picturesque Landscape in Britian, 1750-1850, Cambridge, 1981.
Clark	Kenneth Clark, The Gothic Revival, 1928, new ed. 1962.
Hipple	Walter John Hipple, The Beautiful, The Sublime and the Picturesque in Eighteenth-Century British Aesthetic Theory, Carbondale, Ill., 1957.
Hussey	Christopher Hussey, The Picturesque: Studies in a point of view, 1927, new ed., 1967.
Manwaring	Elizabeth Wheeler Manwaring, Italian Landscape in Eighteenth Century England: a study chiefly of the influence of Claude Lorrain and Salvator Rosa on English taste, 1700-1800, New York, 1927, reprinted, 1965.
Pearson	William Pearson, a Journal of an Excursion to ye North of England A.D. 1838. Containing Partly: things true but not new; Partly: things new but not true, (Newcastle upon Tyne Central Library MS L942. 899618).

The Topographers

Burton	Anthony and Pip Burton, The Green Bag Travellers, Britain's First Tourists, 1978.
Hardie	Martin Hardie, Water-colour Painting in Britain, 3 vols., 1967.
Hussey	Christopher Hussey, The Picturesque: Studies in a Point of View, 1927, new ed. 1967.
Moir	Esther Moir, The Discovery of Britain: The English Tourists, 1540-1840, 1964.
Nicholson	Norman Nicholson, The Lakers: The adventurers of the first tourists, 1955.
Pearson	William Pearson, A Journal of an Excursion to ye North of England A.D. 1838. Containing Partly: Things true but not new, Partly: Things new but not true, (Newcastle upon Tyne Central Library MS L942. 899618).
Plumptre	James Plumptre, Cambridge University Library, Add. MS 5814/5/6 (3 vols.).
Prideaux	S.T. Prideaux, Aquatint engraving: a chapter on the history of book illustrations, 1909.
Roget	J.L. Roget, History of the 'Old Water-Colour' Society, 2 vols., 1891.
Russell	Ronald Russell, Guide to British Topographical Prints, 1977.

The Antiquarians

Brown	Iain Gordon, The Hobby Horsical Antiquary, Edinburgh, 1981.
Cambridge	The Cambridge History of English Literature, vol. XIV.
Kendrick	T.D. Kendrick, British Antiquary, 1950.
Lipking	Lawrence Lipking, The Ordering of the Arts in Eighteenth-Century England, Princeton, 1970.
Piggott	Stuart Piggott, Ruins in a landscape: Essays in Antiquarianism, Edinburgh, 1976.
Pope-Hennessy	Una Pope-Hennessy, Durham Company, 1941.
Surtees Society	Family Memoirs of Rev. William Stukeley, etc., Proceedings of the Surtees Society, Durham, vol. 80.
Walters	H.B. Walters, The English Antiquarians of the Sixteenth, Seventeenth and Eighteenth Centuries, 1934.

Views of Northumberland and Durham

Atkyns	John Tracey Atkyns, Iter Boreale, YCBA MS 1732.
Benedikz	Phyllis M. Benedikz, Durham Topographical Prints up to 1800, 1968.
Defoe	Daniel Defoe, Tour Through England and Wales, 1724-6.
Pearson	William Pearson, A Journal of an Excursion to ye North of England A.D. 1838. Containing Partly: things true but not new; Partly: things new but not true. (Newcastle upon Tyne Central Library MS L942. 899618)
Plumptre	James Plumptre, Cambridge University Library, Add. MS 5814/5/6 (3 vols.)

Monographs

Callcott	David Blayney Brown, Augustus Wall Callcott, Tate Gallery, 1981.
Clennell	Iain Bain, Thomas Bewick, an illustrated record of his life and work, Tyne and Wear County Council, 1979 Luke Clennell 1781-1840: No. 3 in a series of catalogues of the collection, Tyne and Wear County Council, 1981.
Cotman	A.E. Popham, The Etchings of John Sell Cotman, The Print Collector's Quarterly, Oct. 1922. A.P. Oppé, The Water-Colour Drawings of John Sell Cotman, The Studio, 1923. Sydney D. Kitson, The Life of John Sell Cotman, 1937. Victor Reinaeker, John Sell Cotman 1782-1842, 1953.

Miklos Rajnai and Marjorie Allthorpe – Guyton, John Sell Cotman, Early Drawings (1798-1812) in Norwich Castle Museum, 1979.
Adèle M. Holcomb, John Sell Cotman in the Cholmeley Archive, North Yorkshire County Record Office Publications No. 22, 1980.

Daniell Thomas Sutton, The Daniells, Artist and Travellers, 1954.

Dayes R.W. Lightbown (ed.), The Works of the late Edward Dayes, 1974.

Farington Joseph Farington, Watercolours and Drawings, catalogue of exhibition organised by Bolton Art Gallery, 1977.

Girtin Thomas Girtin and David Loshak, The Art of Thomas Girtin, 1954.
Francis Hawcroft, Watercolours by Thomas Girtin, catalogue of exhibition held in the Whitworth Art Gallery, Manchester and Victoria and Albert Museum, 1975.

Glover Basil S. Long, John Glover, Walker's Quarterly, vol. XV, 1924.

Grimm Rotha Mary Clay, Samuel Hieronymous Grimm, 1941.

Place Richard Tyler, Francis Place 1647-1728, catalogue of exhibition held in York City Art Gallery and Kenwood , 1971.

Turner W.G. Rawlinson Turner's Liber Studiorum, 1828.
W.G. Rawlinson, The Engraved Work of J.M.W. Turner, 1908.
A.J. Finberg, The Life of J.M.W. Turner, R.A., 2nd. ed. 1961.
Royal Academy, Turner, Bicentenary Exhibition Catalogue, 1974.
Andrew Wilton, Turner in the British Museum, exhibition catalogue, 1975.
Martin Butlin and Evelyn Joll, The Paintings of J.M.W. Turner, 1977.
Andrew Wilton, The Life and Work of J.M.W. Turner, 1979.
Andrew Wilton, Turner and the Sublime, Toronto, 1980.
John Gage, Correspondence of J.M.W. Turner, 1981.

Varley Randall Davies, John Varley, Old Water-Colour Society's Club, vol. II, 1924-5, pp. 9-27.